LEGENDARY LOCALS

OF

CHARLESTON

SOUTH CAROLINA

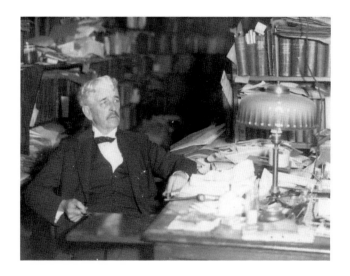

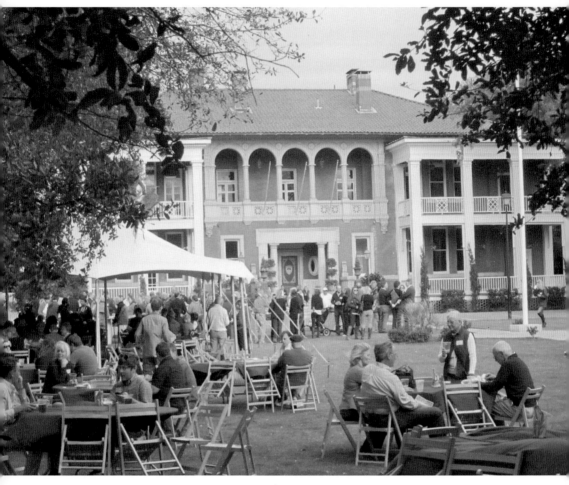

The Preservation Society of Charleston

Since 1920, the Preservation Society of Charleston has worked to save houses, buildings, and neighborhoods with remarkable success. Its programs are supported by its Fall Tours of Homes and Gardens, which is in its 37th year in 2013. The society presents Carolopolis Awards each year to honor outstanding achievements in preservation. In 2011, the Charleston African American Preservation Alliance was formed to bring together preservation groups from all over the community. The photograph shows a membership drive and fundraiser held on the lawn of Quarters H and I at the Charleston Naval Shipyard. Quarters A was on the Seven to Save list of threatened properties in 2011. Each year, the group chooses Seven to Save as a focus. (Preservation Society of Charleston.)

Page 1: Yates Snowden

Snowden, born in Charleston and a graduate of the College of Charleston, published a five-volume *History of South Carolina*, which was reissued in 2011. See page 72 for more information. (South Caroliniana Library.)

LEGENDARY LOCALS
——— OF ———

CHARLESTON
SOUTH CAROLINA

MARY PRESTON FOSTER

Legendary Locals is an imprint of Arcadia Publishing
Charleston, South Carolina

Printed in the United States of America

Library of Congress Control Number: 2012952393

For all general information, please contact Arcadia Publishing:
Telephone 843-853-2070
Fax 843-853-0044
E-mail sales@arcadiapublishing.com
For customer service and orders:
Toll-Free 1-888-313-2665

Visit us on the Internet at www.arcadiapublishing.com

Dedication
To all of the people who call Charleston home and those who visit and appreciate what has been preserved here

On the Front Cover: Clockwise from top left:
Firefighters (Courtesy of Library of Congress; see page 49), Bertha "Chippie" Hill (Courtesy of Library of Congress; see page 96), Josephine Humphreys (Courtesy of Avery Locklear; see page 111), Mary Moultrie (Courtesy of The Citadel Archives and Museum; see page 108), Thomas Sanders McMillan (Courtesy of Library of Congress; see page 79), Footlight Players (Courtesy of Eugene Johnson DeVeaux; see page 90), John James Audubon (Courtesy of Library of Congress; see page 35), Gen. William Moultrie (Courtesy of Library of Congress; see page 23), Mayor Joe Riley (Courtesy of Mayor Riley; see page 110).

On the Back Cover: From left to right:
Anita and Jerry Zucker (Courtesy of Anita Zucker; see page 114), Adm. Creed C. Burlingame (Courtesy of US Navy History and Heritage Command; see page 88).

CONTENTS

ACKNOWLEDGMENTS

For generations, Charlestonians have donated public and private papers, letters, and photographs to the Charleston Library Society, the South Carolina Historical Society, the Avery Center, and the Charleston Museum to make them available to researchers. Silver and furniture were donated to the museum and given to be used in the house museums. Art was donated to the Gibbes Art Museum. The generosity of the community has made it possible to study Charleston's history on a level found in few other places. People have cared enough to save the old houses and the trappings of life through the ages here. Archivists at the Addlestone Library at the College of Charleston are working to catalogue the holdings of every institution and make the resources available on the Internet to scholars all over the world.

The historical photographs in this book came from the Library of Congress and other library collections. The more modern photographs came from private family collections, and many are being published here for the first time. Contemporary photographs were donated by the subjects or taken by the author.

INTRODUCTION

The original founders of Charles Town came from England or were English people who had migrated to the islands of the West Indies. They were hardy adventurers who came in search of riches and a better life. They were soon joined by an influx of French Huguenots, Protestants fleeing persecution by the French Catholic government. The English distrusted the French at first. It took time for the two groups to learn to get along. A group of Scots came, led by Lord Cardross, who made a settlement to the south called Stuart Town. This settlement was not successful, and the Scots moved into Charles Town. Irish and Germans came in groups. Sephardic Jews came from Spain and Portugal. Notes from a 1696 council meeting say that Indians from Florida came to trade, and they were able to communicate because they had a Jew to interpret. Slaves were imported from Africa to support the agricultural enterprises. With enforced religious tolerance and a determination to succeed, they formed a community that worked and attracted disgruntled settlers from all of the colonies.

Over time, these people suffered through devastating fires, earthquakes, hurricanes, and attacks by the French, the Spanish, and Indians. In 1781, the British invaded and occupied Charleston for almost two years. The officers chose the most opulent houses for their headquarters. They made prisoners of the defenders and housed them on ships in the harbor or sent them to St. Augustine, leaving the women, servants, and civilians to deal with a city full of enemy troops. From August 29, 1863, until the end of the Civil War, Charleston was bombarded daily with 200-pound shells fired from a cannon called the "Swamp Angel," located on Morris Island, and ships blockading the port. Then, in 1865, when the Civil War ended, the city was occupied by federal troops until 1876. Again, the officers selected the opulent houses to become their headquarters. The owners of the houses so chosen could leave their belongings in the hands of the enemy or stay put and deal with the occupiers. People survived these assaults because they took care of each other. A bond was formed that has not been broken. They found that the formal manners they had been taught served them well when they were faced with chaos. That may be why Charleston is still considered one of the most mannerly cities.

From the earliest time, Charleston has been a cultural center. It had one of the first city colleges, the first private library society, the first city museum, and one of the first theaters in the country. Its charities have always been supported with elaborate balls and forms of entertainment. Its port has kept it cosmopolitan and ensured a lively night life. The Spoleto Festival has brought many new residents who support the arts and contribute to the ambiance. Charleston people have always seemed more sophisticated than their inland neighbors.

Individuality is prized by the people of Charleston. Independent thinkers are readily accepted. Cussedness is tolerated better than dullness. The most outrageous behavior might be excused with a "Bless his heart. His daddy was a wild one too." As long as the rules of manners and honor are followed and no one is harmed, people can live like they want. A groomsman escorting his decrepit grandmother down the aisle at his sister's wedding said, "Oh, for heaven's sake. This could take all day." With that, he picked her up and carried her to her seat while everyone giggled. And there was the professor who wore sandals with socks and rode his bicycle everywhere with his long, white beard flapping in the breeze.

The political history of Charleston reflects independence and orneriness. The original province was financed by eight lords proprietors who had been given all of the land from Virginia to Florida from the Atlantic Ocean to the South Seas for their part in restoring the monarchy to England in the person of Charles II. The settlers never enacted into law the Fundamental Constitutions given them by John Locke as the basis for setting up the government, but his concepts were adopted. Letters written by the settlers to Lord Ashley have been published as the *Shaftesbury Papers* and provide insight into the daily struggles. The proprietors appointed a succession of governors, and some were better than others.

Progress was made, and the economy flourished under the good governors while bickering, complaints, and stagnation came with the bad ones. The people came to know that they needed a voice in the selection process. When the province started finding success in its Indian trade and indigo and rice planting operations, the proprietors instituted a duty on exports to recoup some of the money they had invested, and the people rebelled. They went to the king and asked to be made a royal colony. The king complied. When the king instituted a tariff on goods imported, the people joined in the Revolution, denying the king what he thought was due him. Is it any wonder that when the US government made laws that South Carolina found to interfere with the balance of trade, South Carolina seceded from the Union? It was said that by the end of the Civil War, South Carolina was seceding from the Confederacy, and Charleston was seceding from South Carolina.

Whatever form the government may take, the people of Charleston will argue for their individual rights and complain about anything that takes money from their pockets. They will give generously to take care of one another but will resent government interference in their affairs. They will guard their traditions and protect their past while supporting the arts and entertainments that make life fun.

History books record the mighty deeds of the important people who contributed to making the society what it was. That puts the focus on the elite, the top 10 percent of the population. It must be remembered that for each of the people cited here, there were many more brave and capable people who performed acts of kindness and generosity every day that never got recorded.

CHAPTER ONE

Trepidation, Manifestation, and Affirmation

1670–1799

The voyage of the very first settlers was fraught with danger. The ocean crossing was uneventful, but they arrived in Barbados and were hit by a series of hurricanes that destroyed one of their three ships and extensively damaged another. The trip from Barbados to the settlement site took six months, and their supplies became depleted. The Cassique of the Kiawah tribe talked them into moving the settlement from Port Royal to his territory on the Ashley River, but the people were determined to succeed and did everything necessary to make their new home livable and attractive to immigrants. By 1680, the settlement had moved from the Ashley River site to the peninsula, and a town began to take shape loosely based on the Grand Modell suggested by the proprietors. Each family was given a town lot and a number of acres outside of the town on which to grow their food. Farmers succeeded and expanded their holdings to create great plantations where they grew rice and indigo as money crops. Those with limited agricultural knowledge thrived as merchants and ship owners. Skilled craftsmen always had work as the farmers, and merchants built ever-larger houses and businesses. Enslaved Africans were imported in great numbers to do the grueling work that rice and indigo growing required. Slaves who came from the rice-growing areas of Africa were particularly valuable to the plantation owners who were still learning the peculiarities of rice production. As the people prospered, they used their wealth to import the luxuries that the rich in England enjoyed. They educated their children in England and traveled abroad for their own pleasure. It is significant that the richest man in South Carolina in the 1700s was a merchant, not a planter. The Revolutionary War years brought the economy to a standstill, and it took years for it to recover.

Lord Anthony Ashley Cooper, 1st Earl of Shaftesbury (1621–1683)

Lord Ashley was the proprietor most responsible for the South Carolina province and he remained the arbiter of the complaints of the settlers with the other proprietors. He was the one they wrote to and nearly all of the letters have been preserved in the *Shaftesbury Papers*. The settlers never felt that the proprietors did enough to support them and liked very few of the governors that the proprietors provided. Lord Ashley had problems of his own in the volatile politics of 17th-century England and landed in the Tower of London twice. When the chance at profits was within reach, he saw the people rebel and seek the protection of George I, the King of England. He accepted their petition, and South Carolina became a royal colony. (Portrait by John Greenhill; courtesy of the National Portrait Gallery of London.)

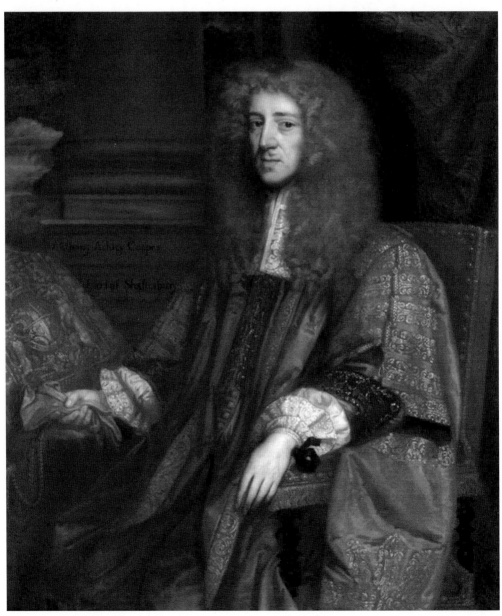

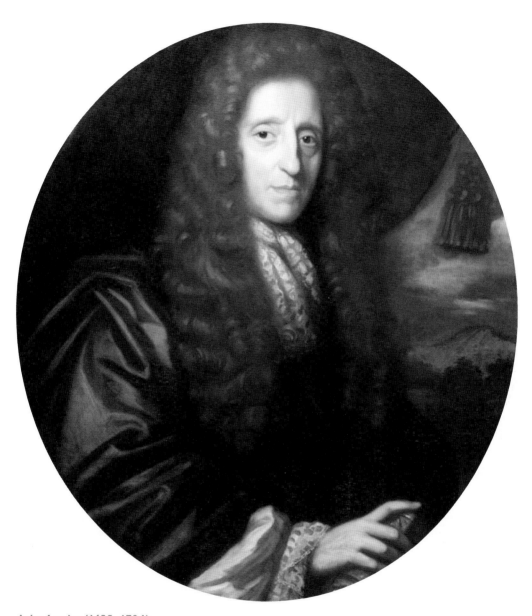

John Locke (1632–1704)

John Locke was an English physician and philosopher who was employed as Lord Ashley's personal physician. He became secretary of the Board of Trade and Plantations and to all of the proprietors. He wrote the Fundamental Constitutions of Carolina that guided the governance of the province, giving him a chance to create his own utopia. His constitution guaranteed the rights of individuals in religion and property matters and protected the rights of the Indians. A governor was appointed to represent the proprietors with an elected parliament and a council. He distrusted a government powerful enough to persecute individuals. He also distrusted the potential power of large groups possible in a democracy. If Locke were in a protest march, his sign might read, "Question Authority." His Fundamental Constitutions of Carolina were never ratified, and historians minimize their importance, but his philosophy is certainly reflected in South Carolina's history and echoes through the Constitution of the United States. (Portrait by Herman Verelst; courtesy of the National Portrait Gallery of London.)

11

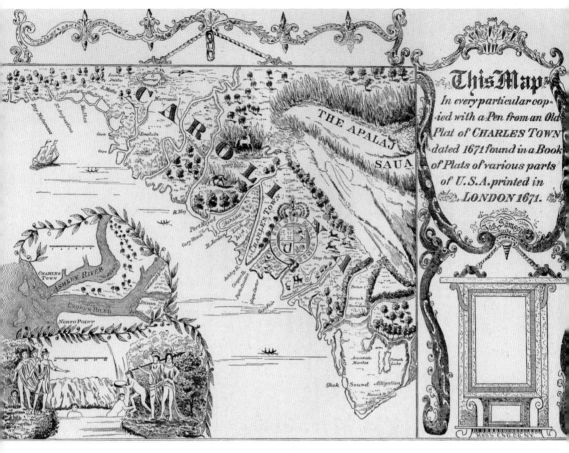

Henry Woodward (1646–1686)

Henry Woodward was the first English settler in the South Carolina colony. In 1666, he got off the ship of Robert Sandford and stayed behind with the Cusabo Indians on St. Helena Island to learn their ways and their language in preparation for the first settlers' arrival. He was the ship's doctor and stayed as security for the chief's nephew, who sailed with Sandford. After six months, he contacted the Spanish priest in the area and asked "in good Latin" that the Spanish from St. Augustine rescue him. The Spanish came, and he lived in St. Augustine until the British privateer Robert Searles attacked that city. Henry sailed with Searles to the Caribbean, working as a ship's surgeon for the privateers. He was shipwrecked on Nevis Island when he was found there by the first settlers headed to South Carolina. He joined their expedition, arriving with them on the first ship. He was not given a plot of land, because he was not on the ship's register. He was a hitchhiker who proved invaluable to the colony. He bargained with the nearby Indians to feed the colonists until they could get crops in and set up trade with the Indians in furs and deerskins to sell in England. He explored the region for hundreds of miles, establishing friendly relations and trade agreements with the Indians. He traveled overland to Virginia and went to England to meet with Lord Ashley and his secretary John Locke. He befriended the Westo tribe who were warlike and terrorized the other tribes. His letters to John Locke describe the life and culture of the Indians he met. He married several times and had two sons, Richard and John, with Mary Browne, the widowed daughter of Col. John Godfrey. They lived in Charles Town and had a plantation on Johns Island. He was awarded 2,000 acres by Lord Ashley for serving as his deputy. His sons remained in South Carolina and fathered an adventurous and illustrious progeny that included most of the important people to come. (University of Texas Libraries, the University of Texas at Austin.)

Col. William Rhett (1666–1722)
William Rhett's father, Baron Walter de Raedt, accompanied Charles II from the Hague to England, and William came to Charles Town as comptroller of customs. He successfully defended Charles Town when it was attacked by the French and the Spanish and led the fleet that captured Stede Bonnet, the pirate. He was married and had six daughters and one son who lived to maturity. His son had no sons; therefore, future descendants took the Rhett name so it would not die out. The Smith-Rhett coat of arms was painted by Alicia Rhett. (Courtesy of Louise Rhett Perry.)

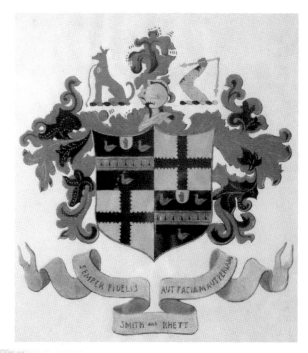

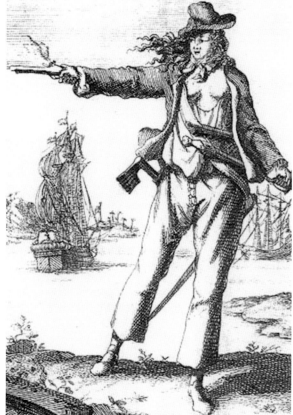

Anne Bonny (c. 1700–1782)
Born in Ireland, Anne Bonny, shown in this 18th-century engraving, was brought to Charles Town by her family as a child. Her father became a merchant and had a plantation. Anne married a poor sailor, James Bonny, and moved with him to Nassau. Leaving Bonny, Anne went pirating with John "Calico Jack" Rackham and had his child. He was hanged when they were caught, but she was spared because she was pregnant. One account says that she made it back to Charles Town, had Rackham's second child, and then married Joseph Burleigh and had 10 more children. (Engraving from *A General History of the Pyrates,* Capt. Charles Johnson, 1724.)

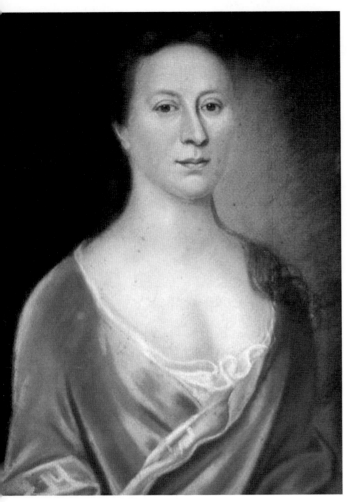

Henrietta de Beaulieu Johnston (1675–1729)

Henrietta Johnston is known as the first female commercial artist in the colonies. She was the widow of Robert Dering and had two daughters when she married Gideon Johnston, who was appointed the first commissary of the Church of England and rector of St. Philip's Church in Charles Town. She arrived alone in Charles Town in 1708; her husband had gotten off the ship in Madiera and the ship had sailed without him. St. Philip's Church had elected a minister who lived in the parsonage, and Reverend Johnston's appointment had to be enforced leaving bitter feelings with the congregation. His pay from the bishop was sketchy, and Reverend Johnston's letters say that his wife's drawings were keeping them fed. She did this portrait in pastels. Reverend Johnston died in 1715, and Henrietta did not remarry. (Courtesy of the New York State Museum.)

Ralph Izard (1741–1804) (OPPOSITE)

Orphaned at a young age, Ralph Izard spent his childhood in schools in England, returning home in 1764. He attended the Continental Congresses in 1782 and 1783 and became a US senator in 1788 serving as its president pro tempore. He donated his estate to be used for warships for the Revolution and was a founder of the College of Charleston. He married Alice DeLancey, and they had 13 children. (Portrait by John Singleton Copley; courtesy of Boston Museum of Fine Art.)

Rev. Alexander Garden (1685–1756)

Reverend Garden was the second commissary of the Church of England and rector of St. Philip's Church from 1719 until 1754. Twice a year, he wrote the Bishop saying that he must return home because the climate here did not agree with him. He finally returned to England when he retired but returned because the climate in England did not agree with him. He established a school for African Americans and tried to stop George Whitefield and the Methodists. (*Charleston: The Place and the People*, 1906.)

THE SECOND ST. PHILIP'S CHURCH
From an old print.

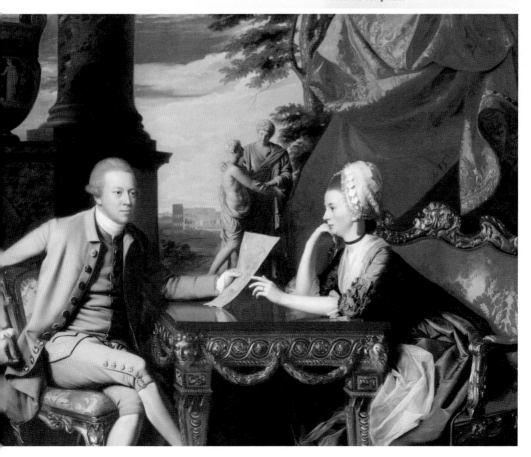

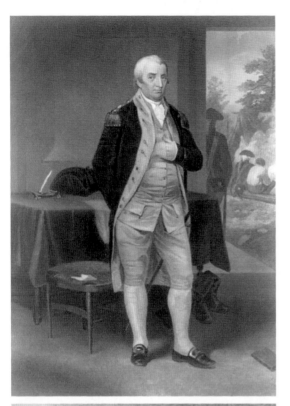

Charles Cotesworth Pinckney (1746–1825)

Charles fought in the Continental Army with George Washington, achieving the rank of major general. He defended Charles Town, becoming a prisoner when Charles Town fell to the British. He was a delegate to the Constitutional Convention and was nominated for president twice, running against Thomas Jefferson and James Madison. The present market sits on land he donated for that purpose. He married Sarah Middleton and Mary Stead and had three daughters. (Courtesy of the Library of Congress.)

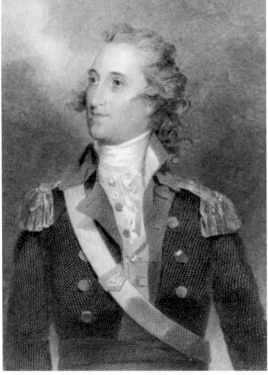

Thomas Pinckney (1750–1828)

Thomas fought in the Revolutionary War with Horatio Gates and Lafayette. In the War of 1812, he became a major general. He served as governor of South Carolina and as a representative. George Washington made him ambassador to Great Britain and later to Spain. He was a candidate for president in 1796. He married twice, first to Elizabeth Motte, and, after her death to her sister Frances. Both were daughters of Rebecca Brewton Motte. He had two sons. (Courtesy of the Library of Congress.)

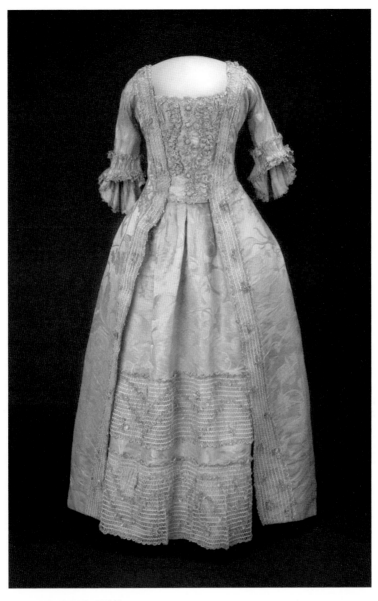

Eliza Lucas Pinckney (1716–1793)

Eliza Pinckney was the mother of Charles Cotesworth and Thomas. Her father was the governor of Antigua, where she was born, and he educated her in England. He came to South Carolina when he inherited two plantations from his father, bringing his wife and Eliza. When she was just 16 years old, she assumed responsibility for those plantations while her father returned to Antigua. She and her neighbor Andrew DeVeaux experimented with growing indigo and processing it to make blue dye. Their success established a new money crop for the state. She was also successful in the culture of silk. The photograph shows a silk dress she made from the silk she harvested. It is in the Smithsonian. She married Charles Pinckney, a rice planter, and they had three children. Eliza was living with her daughter, Harriott Horry, at Hampton Plantation when George Washington stopped there. She died and was buried in Philadelphia. George Washington was there and acted as Eliza's pallbearer at his own request. (Courtesy of the American History Collection, Smithsonian Institution.)

Nicholas Trott (1663–1740)

Nicholas Trott was awarded his doctorates from Oxford and Aberdeen College for his scholarly books on the law. He was the judge in the trial of Stede Bonnet and his crew. Each of the accused claimed that he had not known that Bonnet was a pirate; that he had signed on as a passenger; and when Bonnet started taking ships, that there was nothing he could do. Trott asked each if he had shared in the loot. All but three admitted that they had, and all but those three were hanged. Bonnet claimed that he had given up pirating and was just sailing home, but the men took over his ship, and there was nothing he could do. Asked if he shared in the loot, he claimed a black crew member had stored his share in Bonnet's quarters, but the loot belonged to the black man. Bonnet too was hanged. Trott was the brother-in-law of William Rhett, and his second wife was Rhett's widow. He had no children. (Courtesy of the University of South Carolina School of Law.)

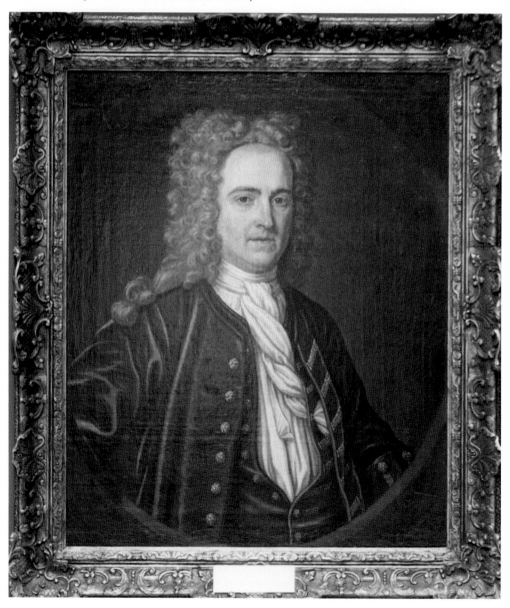

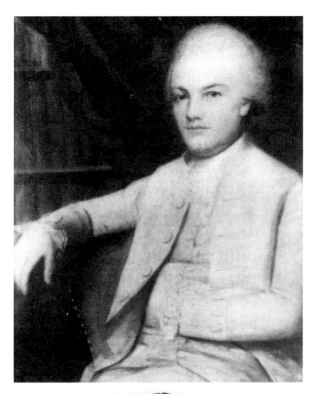

Charles Pinckney
(1757–1824)

Charles Pinckney signed the Constitution and contributed to its development. He served as South Carolina governor four times, as a senator, and in the House of Representatives and as ambassador to Spain. He married Mary Eleanor Laurens, daughter of Henry Laurens, and they had three children. His indigo and rice plantation Snee Farm, where he entertained George Washington, is now a national historic site. Pinckney's cousin was Charles Cotesworth Pinckney, who married Eliza Lucas. (Courtesy of the Library of Congress.)

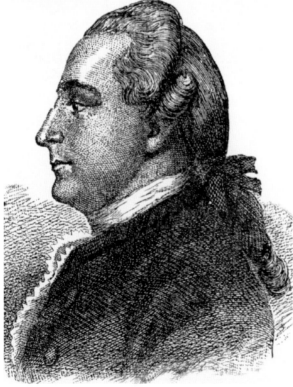

William Henry Drayton
(1742–1779)

William's grandfather William Bull was a popular governor but he remained loyal to the king and died in England. William Drayton, born at Drayton Hall, was a supporter of the Revolution and served as president of the Continental Congress. He gave an order to William Moultrie to fire on British ships even before the signing of the Declaration of Independence. He served as chief justice of the South Carolina Supreme Court. He was married to Hester Middleton. (Courtesy of the Library of Congress.)

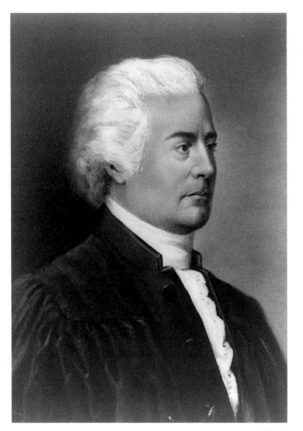

John Rutledge (1739–1800)
John Rutledge signed the Constitution and attended both Continental Congresses. He was president of South Carolina during the Revolution and then governor after South Carolina became a state. He served on the first US Supreme Court and was its second chief justice. When the British took control of Charles Town, someone asked where the capital of South Carolina was, and the answer was, "Wherever John Rutledge's carriage is." He married Elizabeth Grimke and had 10 children. (Courtesy of the US Supreme Court.)

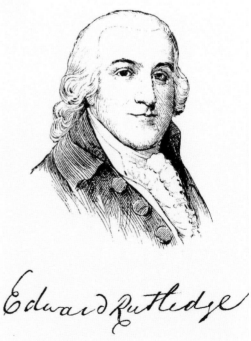

Edward Rutledge (1749–1800)
Edward Rutledge was the youngest signer of the Declaration of Independence. He attended the Continental Congresses and fought in the South Carolina militia. He was imprisoned after the fall of Charles Town and also served as governor. He married Henrietta Middleton, and they had three children. In the play and movie *1776*, he is portrayed as opposing John Adams and Thomas Jefferson, but there is little documentation to support that characterization. (US Navy History and Heritage Command.)

Daniel Huger (1742–1799)

Daniel Huger was born on Limerick Plantation in Berkeley County and attended the Continental Congress as a representative of Georgetown, where he also had rice plantations. He was educated in England. He served as a representative in the first two congresses of the United States. His house on Meeting Street remained in the hands of his descendants from 1760 until 2005. He married Sabina Elliott and had one son, Daniel Elliot Huger, a US senator. (Courtesy of the Library of Congress.)

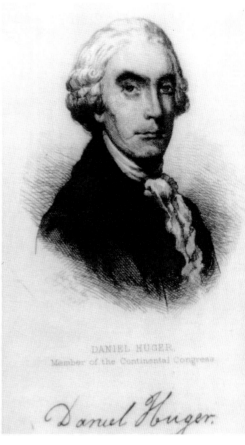

DANIEL HUGER,
Member of the Continental Congress.

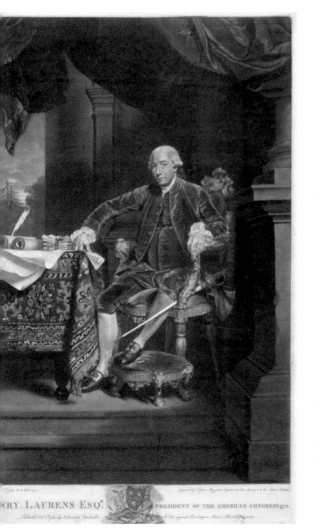

Henry Laurens (1724–1792)

Henry Laurens was president of the Continental Congress and signed the Articles of Confederation. He served as ambassador to the Netherlands and became the only American imprisoned in the Tower of London when his ship was seized by the British. He was returning home after gaining support for our revolution from the Dutch. He married Eleanor Ball, and they had 12 children. (Courtesy of the Library of Congress.)

21

Isaac Hayne (1745–1781)

Isaac Hayne was a rice planter near Jacksonboro when the Revolutionary War began. When Charles Town fell to the British in 1780, he was captured as one of the city's defenders. His wife and three of his children were dying of smallpox, so he took the parole offered so he could go home. Isaac's wife and two of his daughters died, and he went back to war. When he was captured, the British court-martialed him as a traitor rather than hold him as a prisoner of war because of his 1780 parole. He was held in the Provost Dungeon while powerful people argued his case. He was hanged on August 4, 1781, causing an uproar here and in England. Hayne was married to Elizabeth Hutson, and they had seven children. (Courtesy of the Hayne family.)

Henry Middleton (1717–1784)
Henry Middleton was elected the first president of the first Continental Congress in 1774 and served as president of the Provincial Congress of South Carolina. His plantation home, Middleton Place, reflected the best of country landscaping and retains his basic design. He had 12 children by his first wife, Mary Williams, and had two wives after her death: Maria Henrietta Bull and Mary McKenzie. (Courtesy of the Library of Congress.)

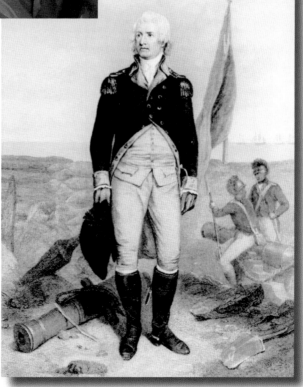

William Moultrie (1730–1805)
On June 26, 1776, William Moultrie commanded the troops at Fort Sullivan and prevented the conquest of Charles Town by Sir Peter Parker's British fleet. He was made a brigadier general in the Continental Army and Fort Sullivan was named for him. He also served as governor of South Carolina twice and designed a flag with a crescent moon that evolved into the flag of South Carolina. He married Elizabeth St. Julien and, upon her death, he married Hannah Motte Lynch. (Courtesy of the South Caroliniana Library.)

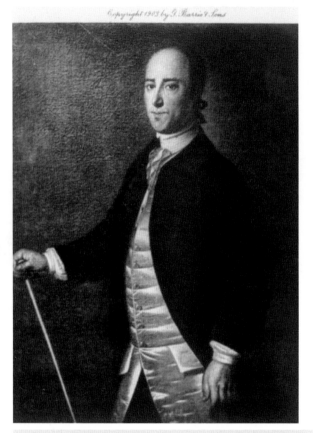

Christopher Gadsden (1724–1805)

Christopher Gadsden attended the Continental Congress and was a leader of the Sons of Liberty. He became a brigadier general in the Continental Army. When he was imprisoned after the fall of Charles Town in 1780, he refused to sign a parole and so was kept in the dungeon of the Spanish Castle of San Marco. He is buried in an unmarked grave at St. Philip's Church. He married three times and had four children. (Courtesy of the Library of Congress.)

Don't Tread on Me

The flag that Christopher Gadsden designed showed a snake's body broken into segments to show the dissolution of the British Empire. Its "Don't Tread on Me" message was a direct threat from the American colonies. It was very popular with the American troops and has enjoyed a comeback of sorts in recent years for its defiant political message. (Courtesy of Lexicon, Vikrum.)

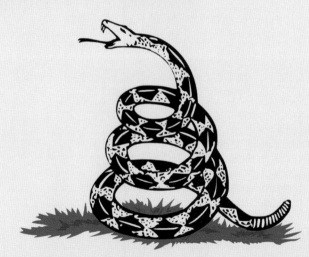

DONT TREAD ON ME

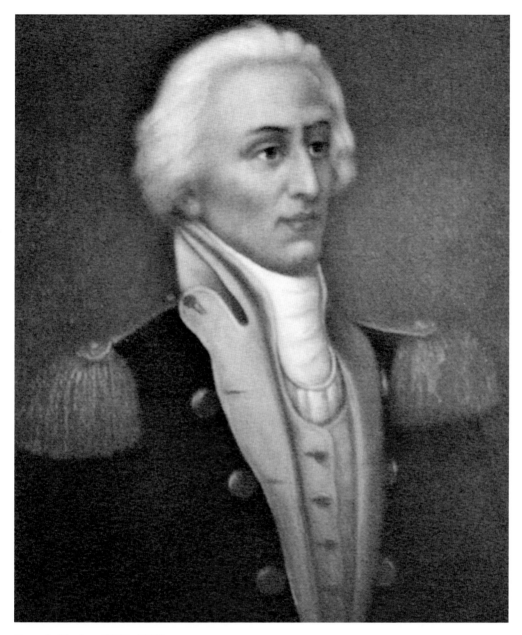

Francis Marion (1732–1795)

Francis Marion was a hero of the Revolution who attained the rank of general. His troops consisted of volunteers who fought without pay. He and his men had grown up in the swamps around Charles Town and knew how to maneuver in that environment. He used guerilla warfare tactics because he was always outnumbered by the enemy, and the hit-and-run approach was the only way to win. The British called him the "Swamp Fox" because they could not catch him or stop him. He avoided capture when Charles Town fell because he was on his plantation recovering from a sprained ankle. With the defenders of Charles Town imprisoned, he and his men were the only forces then available in the area to harass the British. His role was important in the ultimate patriot victory. He married Mary Esther Videau but had no children. (South Carolina Statehouse.)

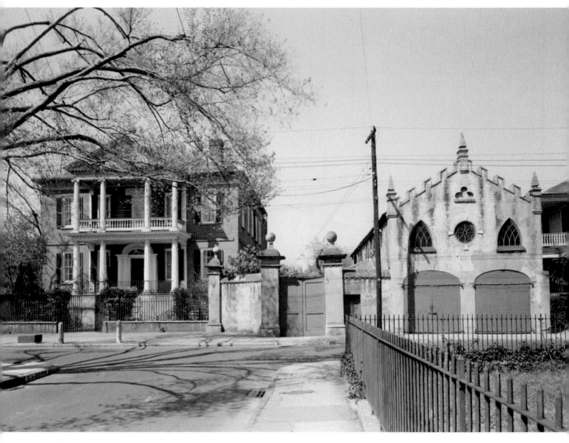

Rebecca Brewton Motte (1737–1815)
When Rebecca's brother Miles Brewton was lost at sea in 1775, she inherited his house on King Street where she and her husband, Jacob Motte, made their home. When Charles Town fell in 1780, it became headquarters for Sir Henry Clinton and later Lord Rawdon, the British commanders. Eventually, she moved her family to her plantation, Mount Joseph, on the Congaree River. British troops also commandeered her Mount Joseph house, moving her family to the overseer's cottage. Francis Marion and Lighthorse Harry Lee were sent to recapture her house. They decided that the quickest way to get the troops out was to set fire to the house, so Rebecca provided them with a bow and arrows to do it. After the war, she bought a rice plantation and managed to pay off all of the family debts accrued by the economic chaos of the war. Her daughter Mary, married Col. William Alston, owner of one of the largest rice plantations in the state. Mary and William entertained George Washington on his way to Charleston. (Courtesy of the Library of Congress.)

David Ramsay (1749–1815)

David Ramsay moved to Charles Town as a physician in 1773, after being educated at Princeton and the University of Pennsylvania. He served in the Continental Congress as its president and in the South Carolina militia. He was imprisoned at St. Augustine after the fall of Charles Town. He also served in the South Carolina legislature. He wrote the first book to be copyrighted in the United States, titled *The History of the Revolution of South Carolina*. It was published in 1785, followed by *The History of the American Revolution* in 1789. Because of his participation in the events and first-hand knowledge of the people involved, his writings are still authoritative. He also wrote *History of South Carolina*, *The Life of George Washington,* and the *History of the United States*. He was shot on Broad Street by a man he had declared deranged. He forgave the man on his deathbed. He was married three times to Sabina Ellis; Martha Laurens, daughter of Henry Laurens; and the daughter of John Witherspoon. He had one daughter, Martha Laurens Ramsay. (Courtesy of the Waring Historical Library.)

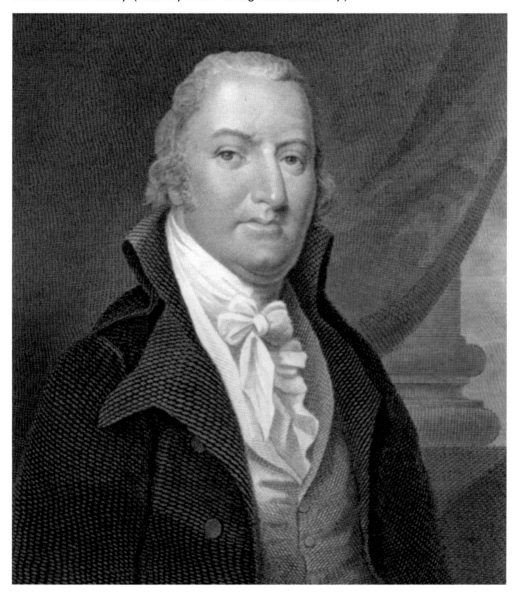

Gabriel Manigault (1758–1809)
Gabriel Manigault was an architect who designed this house for his brother Joseph in 1790. He studied law and architecture in Geneva, Switzerland, and London. He also designed the South Carolina Society Hall on Meeting Street. He was the nephew of Gabriel Manigault, one of the wealthiest merchants in the city, so he was always referred to as a gentleman architect. He was married to Margaret Izard. (Courtesy of the Library of Congress.)

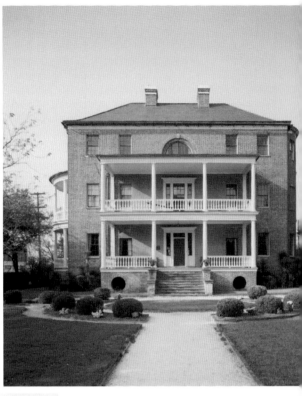

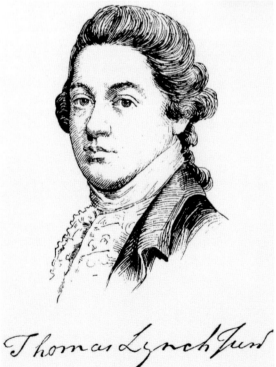

Thomas Lynch (1749–1779)
Thomas Lynch was educated in England and served in the South Carolina militia under Col. Christopher Gadsden. His father became ill while serving at the Continental Congress in Philadelphia, and Colonel Gadsden refused to allow Thomas leave to go to him. It was arranged for Thomas to take his father's place. Thus, Thomas was in Philadelphia to sign the Declaration of Independence. His father died on the way home from Philadelphia, and Thomas was lost at sea shortly after. His rice plantation was called Hopsewee. (Courtesy of the National Park Service.)

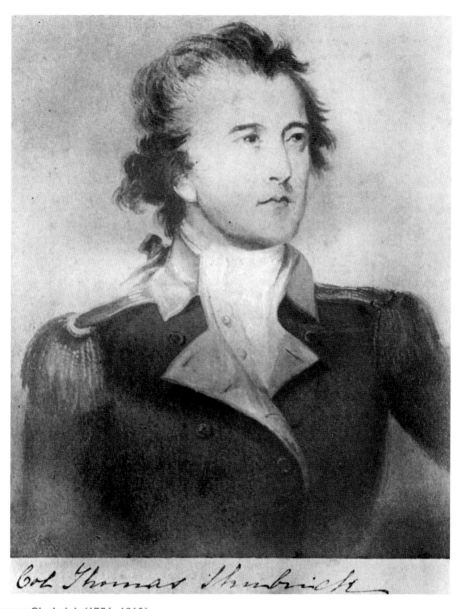

Col Thomas Shubrick

Thomas Shubrick (1756–1810)

Thomas Shubrick was the son of a ship's captain whose rice plantation was called Belvidere. In 1779, Gen. Augustine Prevost and his men were camped on Robert Gibbes's plantation on Johns Island, preparing to attack Charles Town. Prevost's men had stolen all of the horses in the neighborhood, so Thomas Shubrick took volunteers from Benjamin Lincoln's camp on James Island to Robert Gibbes's plantation, and they rescued the horses. Shubrick later served with General Howe and was an aide-de-camp to General Greene, achieving the rank of colonel. He was given a commendation for bravery in the battle at Eutaw Springs. After the war, he was commissioned to provide timber for building two battleships for the US Navy. He planned to harvest the oaks on Shubrick's Island; however, when he cut the trees, he found they had a disease that rendered them unusable. He was only able to provide timber for two-thirds of one ship. He married Mary Branford, and they had 12 children. His four sons all had Navy careers. (Courtesy of the Hayne family.)

Arnoldus Vanderhorst (1748–1815)

The Charleston Orphan House opened in 1790 with Arnoldus Vanderhorst as the first chairman of the commissioners. He served with Francis Marion during the Revolution and later was governor. His plantation was on Kiawah Island. When he was on city council, a yellow fever epidemic left many children homeless. John Robertson, a fellow council member, suggested that the city build and support an orphanage. It was the first municipal orphanage and was in continuous use until 1952. It was designed to be self-sufficient like a plantation, with the girls learning sewing and making the clothes and boys milking the cows and chopping wood and all growing the vegetables. Eventually, a school and chapel were built on the grounds so the children had little contact with the outside world. It was an imperfect system that cared for and educated over 5,000 children over time. (Courtesy of the Library of Congress.)

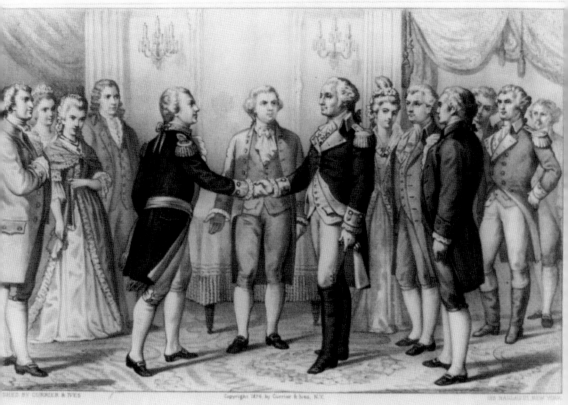

THE FIRST MEETING OF WASHINGTON AND LAFAYETTE.

Philadelphia. August 3rd 1777.

George Washington Meets the Marquis de Lafayette

Although not from Charleston, both of these men made visits that had an impact on the city. George Washington made a tour of South Carolina in 1791 to commemorate the fact that more battles of the Revolution were fought in South Carolina than any other state. He was entertained at a ball at the Exchange Building on East Bay Street and by the Society of the Cincinnati at McCrady's Tavern. He was housed in the Heyward-Washington House on Church Street. The host of one banquet seated Susannah Bulline Shubrick, the prettiest lady in Charleston, across from him, and Claudia Smith (later Mrs. Henry Izard), the wittiest, on his left to assure him a good time.

The Marquis de Lafayette voluntarily came from France to assist in the Revolution. He fought many battles in South Carolina and had many friends in Charles Town. When he was imprisoned by the Austrians years later, it was Francis Huger, a Charlestonian studying in Vienna, who risked all to rescue him. Lafayette was recaptured, but when he visited Charleston in 1825 he thanked Francis for his effort. (Courtesy of the Library of Congress.)

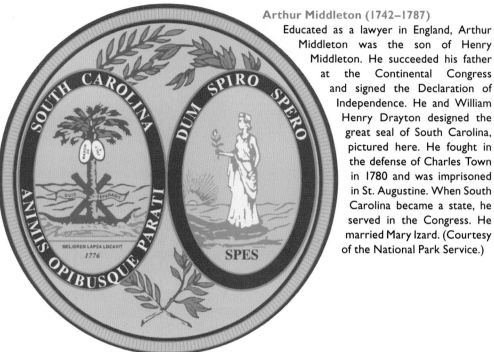

Arthur Middleton (1742–1787)

Educated as a lawyer in England, Arthur Middleton was the son of Henry Middleton. He succeeded his father at the Continental Congress and signed the Declaration of Independence. He and William Henry Drayton designed the great seal of South Carolina, pictured here. He fought in the defense of Charles Town in 1780 and was imprisoned in St. Augustine. When South Carolina became a state, he served in the Congress. He married Mary Izard. (Courtesy of the National Park Service.)

Charles Fraser (1782–1860)

Born in Charleston, Charles studied law and opened a practice but eventually gave it up to pursue his art. He painted in both watercolors and oil. He painted miniature portraits of most of the elite of the city and made landscape paintings of their estates in the country. He was inducted into the American Academy of Fine Arts in 1825. This painting is his portrait of Mary Branford Shubrick, the wife of Col. Thomas Shubrick. (Courtesy of Don Shelton.)

CHAPTER TWO

Jubilation, Desecration, and Re-creation
1800–1899

The 19th century began with the people of Charleston recovering from the devastation of the Revolutionary War and the horror of having been occupied by an invading army. It ended recovering from the Civil War and the horror of having been occupied again. In the 1800s, the role played by rice and indigo was enhanced by the addition of cotton, but the culture remained essentially the same. Cotton did not depend on irrigation from rivers, so large cotton plantations were established in areas previously uncultivated where the land was cheap. A large number of fortunes were made on cotton, and conspicuous consumption was the style. The Greek Revival mansions were built then. Luxuries were imported in large quantities, and the merchants and shippers shared in the wealth.

Then came the Civil War, and those fun-loving, outrageous people faced the deprivations of war and the destruction brought by the defeat. Men who fought in terrible battles and suffered from shortages of all supplies, including food, walked home from wherever the surrender found them to find their homes burned and looted, their animals carried off, and what money they had worthless. The occupation was carried out by soldiers from the US Army, so the streets of Charleston were once again filled with enemy soldiers. The occupation forces were not removed until 1876. The reason the South remembers the Civil War so vividly is that the South had a longer war than the North did. "Genteel poverty" became the term for the people born to wealth and privilege, educated, and well-mannered, who found themselves struggling to survive after the Civil War. Economic upheaval is never easy, though the charitable spirit remained. Harriott Ravenel has a quote: "I have a curtain I haven't cut up yet. I'll send it over for clothes for the baby." Charleston is still full of people like that, and people like that will always rebound.

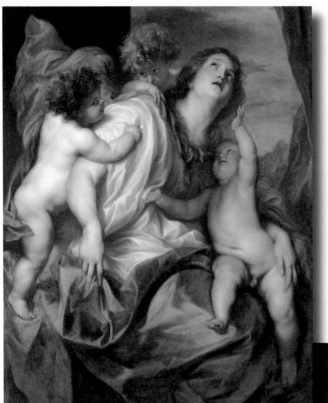

Van Rhyn (dates not known)
Van Rhyn was a Dutch shopkeeper who sold fine Holland linen and Delftware. She was a favorite of the ladies who enjoyed her witty and caustic remarks. When she died, she left a painting called "Charity," which she said had been painted by Van Dyck, to Lynch Bowman. Bowman researched and found that Van Dyck's favorite pupil was named Van Rhyn. The painting was destroyed during the Civil War. (Painting by Van Dyck; courtesy of the National Gallery of London.)

Theodosia Burr Alston (1783–1813)
Educated and raised in New York, Theodosia Burr was the daughter of Aaron Burr, disgraced vice president under Thomas Jefferson. She married South Carolina governor Joseph Alston and lived on his rice plantation in Georgetown, maintaining a house in Charleston. Her only child died, and in deep mourning, she sailed to visit her father, never to be heard from again. Her ship was lost at sea. (Portrait by John Vanderlyn; courtesy of the New York Historical Society Museum and Library.)

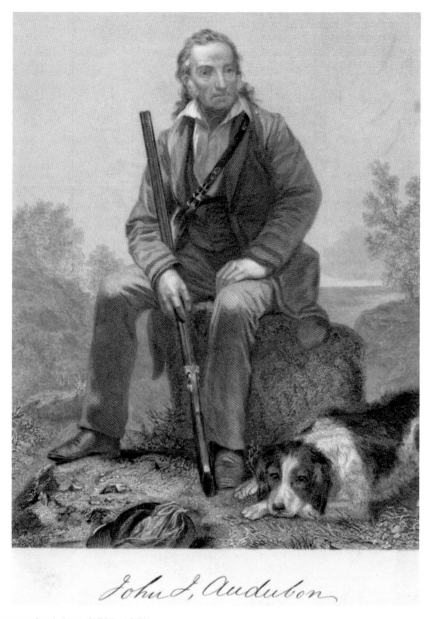

John J. Audubon

John James Audubon (1785–1851)

Audubon had a convoluted background, in that he was born in Haiti, raised in France, and came to America when he was 18 years old. He was a naturalist and artist whose focus was on accurately depicting wildlife in its natural setting. His *Birds of America* identified 25 new species of birds and became an authoritative reference work. Getting that work published involved going to England and Scotland and selling subscriptions. Because he insisted on using life-size portraits of his birds, the size of the book had to be 39 inches by 26 inches, making it prohibitively expensive to produce. It was called a double-elephant folio. Expanding versions of this were published from 1827 to 1839. In 1842, he produced an octavo edition. He came to Charleston around 1831 and became friends with the Rev. John Bachman, a fellow naturalist and ornithologist. He married Lucy Blakewell, and they had two sons who both married daughters of John Bachman. (Courtesy of the Library of Congress.)

Hugh Swinton Legare (1797–1843)

A reaction to a vaccine given before he was five arrested the development of Hugh's legs so he walked with a limp. He served as the South Carolina attorney general and later as the US attorney general and secretary of state. He also served as a US representative for one term. He spent four years in Brussels as the charge d'affaires. He was the editor and founder of the literary magazine *The Southern Review*. (Courtesy of the Library of Congress.)

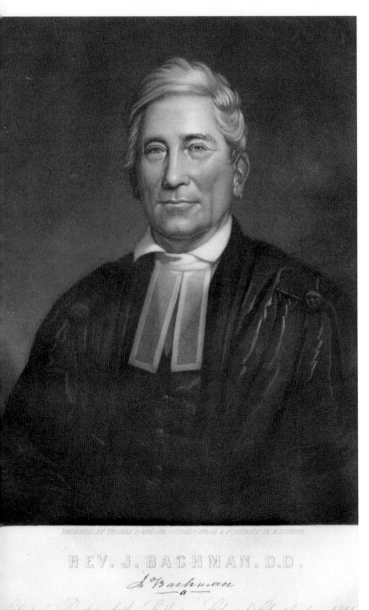

REV. J. BACHMAN. D.D.

J. Bachman

John Bachman (1790–1874)

John Bachman arrived in Charleston in 1815 from his native New York having been hired as the pastor of St. John's Lutheran Church. As a child, John explored the woods in New York with one of his father's slaves who taught John to study and appreciate nature. He ministered to and educated African Americans, baptizing 90 in one year. Politically, he opposed slavery but did not come out as a Unionist. He spent the War Between the States caring for the sick and wounded. Union troops beat him and paralyzed his arm, and Sherman's men destroyed his scientific collections and library. As a naturalist, he paired with Audubon writing the text of works Audubon illustrated. As a theologian, he helped found the Lutheran Synod and the Lutheran Theological Southern Seminary. He also was a founder of Newberry College. Bachman's Hare, Bachman's Sparrow, and Bachman's Warbler were all named for him by Audubon. He married Harriet Martin, and they had 14 children. Upon her death, he married her sister Maria. (Courtesy of St. John's Lutheran Church.)

Robert Mills (1781–1855)

Charlestonian Robert Mills studied architecture with James Hoban, who designed the White House, and Thomas Jefferson, who shared his architecture books with him. Mills designed the Department of the Treasury, the US Patent Office, and churches in several cities before returning to Charleston, where he designed the Fireproof Building and the First Baptist Church. He is best known for the Washington Monument, and this photograph shows his original design that was never completed. He married Eliza Barnwell Smith. (Courtesy of the Library of Congress.)

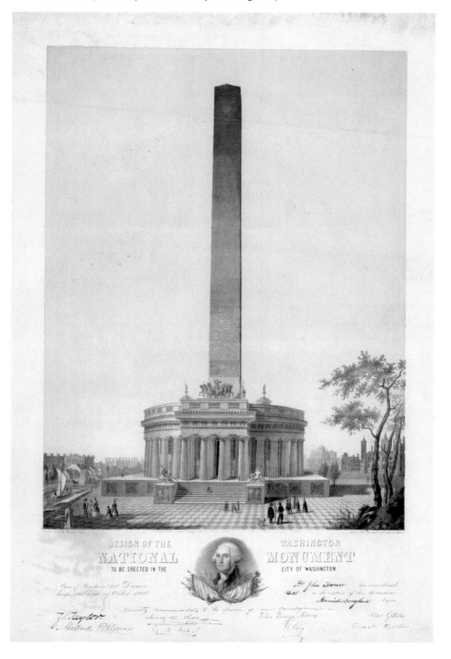

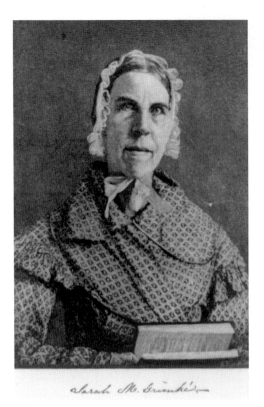 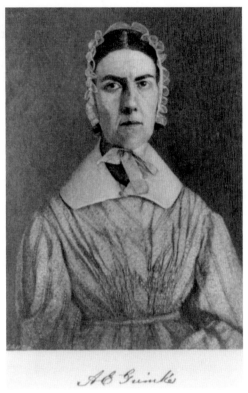

The Grimke Sisters

Sarah Grimke (1792–1873) and her sister Angelina (1805–1879) were abolitionists and feminists. Their father was chief justice of the South Carolina Supreme Court and a planter. Sarah witnessed a slave being whipped when she was five and spent her life fighting to abolish slavery. She and her sister moved north, renounced their inheritance, and became Quakers. In 1838, they addressed the Massachusetts Legislature. That same year, Angelina married Theodore Weld, who arranged speaking engagements for the women to abolition groups around the North. They were ridiculed and criticized by the press. They turned to writing and in 1839 published a book called *Slavery As It Is: The Testimony of a Thousand Witnesses*. The book reproduced unembellished advertisements related to slavery taken from 20,000 newspapers, including the following listing from J.A. Brown, jailer, Charleston, SC in the *Mercury* of January 12, 1837: "Committed to jail a negro man, has no toes on his left foot." The advertisements were all true and real and horrifying. (Courtesy of the Library of Congress.)

Robert Y. Hayne (1791–1839) (OPPOSITE PAGE)

Robert Y. Hayne was the grandson of Isaac Hayne, the martyr. He was a lawyer who served as speaker of the House, attorney general, governor, and the intendant (mayor) of Charleston. He was elected to the US Senate in 1823. In 1830, he debated with Daniel Webster over the relationship between the states and the federal government. Hayne contended that the Constitution was a compact between united states and that each state had the right to nullify a federal law within its borders. Webster contended that such an action would threaten the United States; that the Constitution made all federal laws apply to all citizens. The resentment and ill will between the South and New England became clear. Hayne was president of the Louisville, Cincinnati & Charleston Railroad. He married Frances Henrietta Pinckney and, after Frances died, Rebecca Brewton Alston. He is buried at St. Michael's. (*Appleton's Cyclopaedia of American Biography*.)

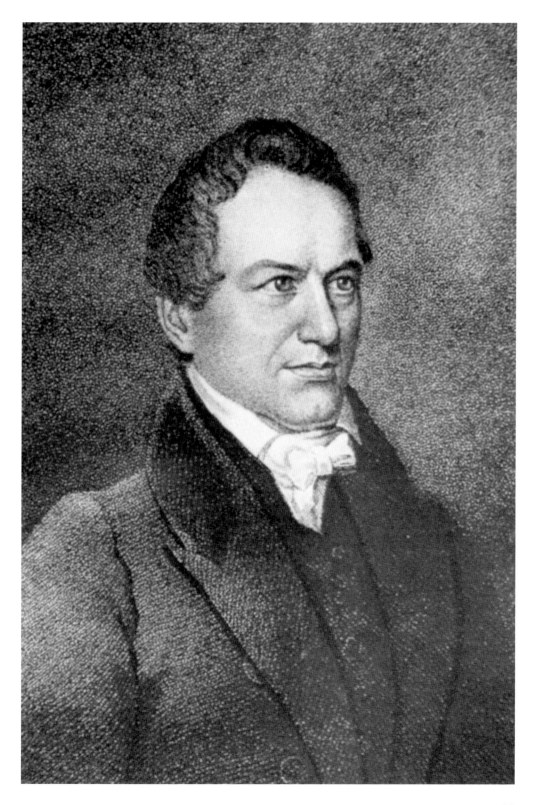

John C. Calhoun (1782–1850)

John C. Calhoun, designated one of the five best senators ever, is buried in the nonmembers section of St. Philip's Church. He was born in the Abbeville District but spent most of his life in Washington in a series of political offices, including vice president twice. His homestead became Clemson College when his son-in-law Thomas Clemson donated the property to the state. In 1832, a crisis was created when South Carolina nullified a tariff imposed by the federal government. Calhoun argued that South Carolina had the right of nullification, but Andrew Jackson sent US Navy ships to enforce the law; Calhoun resigned as his vice president. A compromise was reached, but the nullification problem had not been solved. On slavery, he argued that the states had the right to decide whether to allow slavery or not. He married Floride Bonneau Calhoun, and they had 10 children. (Courtesy of the Library of Congress.)

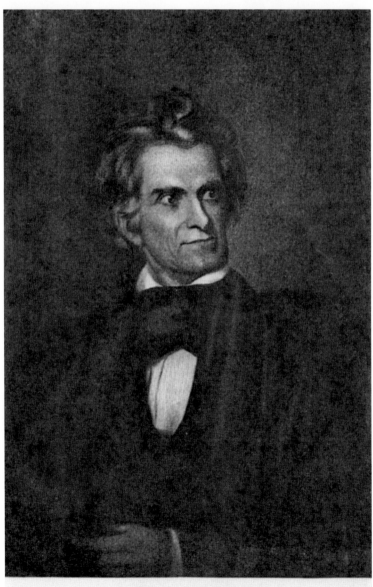

JOHN C. CALHOUN

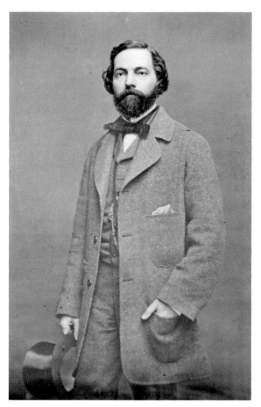

William Porcher Miles (1822–1899)
Born in Walterboro, South Carolina, William Miles attended schools and studied law in Charleston. He was elected mayor of Charleston and then served in the US House of Representatives from 1857 to 1860. He was on Beauregard's staff at the firing on Fort Sumter and then became a representative to the Confederate Congress. He was a states' rights, proslavery secessionist. After the war, he became president of the University of South Carolina. (Courtesy of the Library of Congress.)

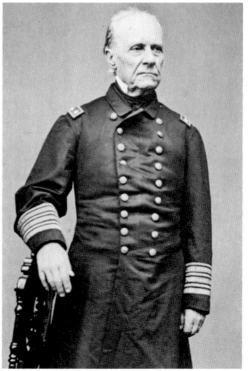

William Branford Shubrick (1790–1874)
William Shubrick was born in Charleston. After graduating from Harvard, he joined the US Navy, serving in the War of 1812 and the Mexican War. He had overall command of the ships protecting California in the Mexican War. He rose to the rank of rear admiral. When South Carolina seceded, he retired from the US Navy but did not join the Confederate navy. His family disowned him, even changing the name of a nephew named for him. He did not return to Charleston. He was a lifelong friend of James Fenimore Cooper. (Courtesy of the Library of Congress.)

41

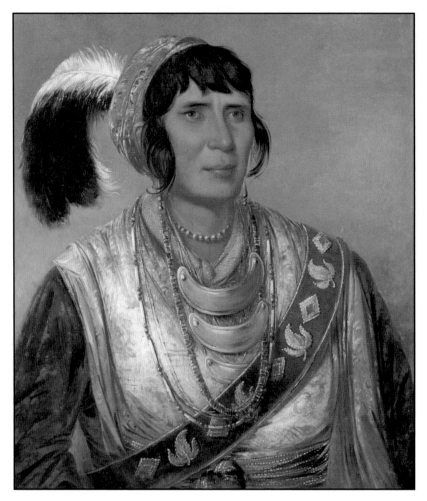

Osceola (1804–1838)

Osceola was named Billy Powell at birth. His father, William Powell, had married his half-Creek mother, Polly Coppinger, but deserted the family in 1813. Billy changed his name to Osceola and was raised in the Creek culture but functioned as well in English society. When the US government started removing Native Americans to be resettled in the West, Osceola led the resistance. The conflict became the Second Seminole War, Seminole being the term used by the US to designate the Native American coalition of tribes and runaway slaves that made up the opposition. Gen. Thomas Jesup led the US troops. By 1837, Osceola sent word that he was willing to negotiate a settlement and a meeting with Jesup was arranged. When Osceola and his men arrived under a flag of truce, against all codes of war, Jesup took Osceola and his men prisoner. Osceola was sent to Fort Moultrie. Because of Jesup's treachery, Osceola was housed in the officers' quarters and allowed to bring his wives and children with him. They were taken to the Dock Street Theatre to see a play. Local dignitaries called, and George Catlin came and painted his portrait. Osceola was suffering from malaria, and Dr. Weedon took care of him. The day that he died, he had his wives assist him in dressing in his Creek chieftain's garb. He stood regally and shook the hands of his captors and bid farewell to his wives and two sons, lay down on his bed with his scalping knife in his hand, crossed his arms, and died with a smile. He was buried with military honors at Fort Moultrie. His artifacts and even his body parts were argued over and moved several times in a way not befitting the honorable warrior that he was. (Portrait by George Catlin; courtesy of the Library of Congress.)

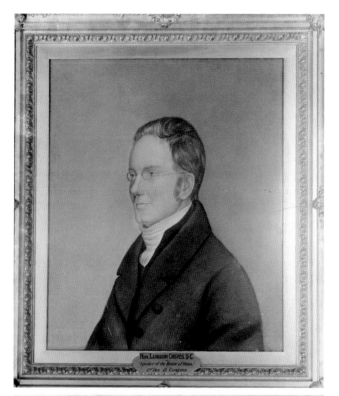

Langdon Cheves
(1776–1857)

Langdon Cheves came to Charleston when he was 10 years old, became a lawyer, and was elected to the House of Representatives, becoming the speaker in 1814. He declined renomination and returned to Charleston where he was made judge of the Superior Court of South Carolina. He also served as president of the Board of Directors of the National Bank. He opposed nullification but favored secession. He married Mary Elizabeth Dulles. (Biographical Directory of US Congress.)

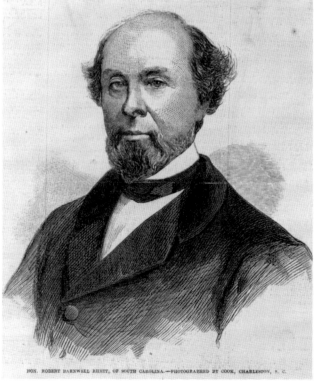

HON. ROBERT BARNWELL RHETT, OF SOUTH CAROLINA.—PHOTOGRAPHED BY COOK, CHARLESTON, S. C.

Robert Barnwell Rhett
(1800–1876)

Born Robert Barnwell Smith in Beaufort, he took the name of his Rhett ancestors when he entered politics. His house in Charleston is in the National Registry. He was a fire-eating radical on the question of slavery being made legal in the expanding US territories. He served as South Carolina attorney general, US representative, and US senator and in the Confederate Congress. He was a strong contender for the presidency of the Confederacy but was considered too radical for even that group. (Courtesy of the Library of Congress.)

43

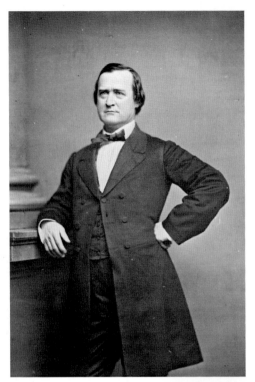

Isaac William Hayne (1809–1880)
Isaac was a Charleston lawyer who served as the South Carolina attorney general from 1848 to 1868. He read the Order of Secession at the Secession Convention. He was sent as special envoy by Governor Pickens to meet with President Buchanan to arrange for South Carolina to buy Fort Sumter and all other federal installations in the state at the time of secession. President Buchanan refused to meet with him. He married Alicia Paulina Shubrick Trapier, and they had 11 children. (Courtesy of the Library of Congress.)

Institute Hall, December 21, 1860
In Charleston, 169 men voted unanimously for South Carolina to secede from the Union in Institute Hall. They left to "protect the good order and harmony of their community from the horror they feared a Republican administration and abolition of slavery would bring: race war and economic disaster," according to Walter Edgar in his book *South Carolina: A History*. The building burned in the fire of 1861. (Courtesy of the Library of Congress.)

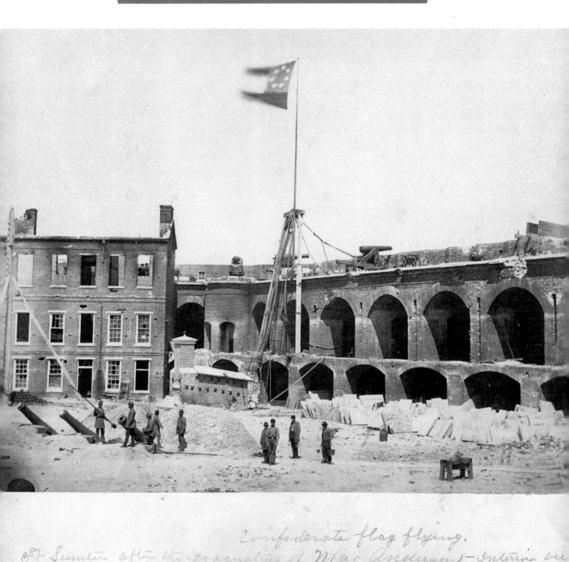

Confederate flag flying.
Fort Sumter after the evacuation of Major Anderson.—Interior view

Fort Sumter

The firing on Fort Sumter on April 12, 1861, began a bloody conflict that lasted until 1865 and left the South in ruins. Between December and April, momentous things happened. Major Anderson moved his men from Fort Moultrie to Fort Sumter, spiking the cannons to disable the fort. President Buchanan sent the *Star of the West* to bring supplies to Anderson, and the ship was fired on and turned back. The Confederacy was formed with six other states that seceded and elected Jefferson Davis its president. Lincoln was inaugurated. General Beauregard took command of the forces gathered in Charleston. When time ran out on Beauregard's ultimatum to Anderson, people gathered on the battery to watch the shots being exchanged. Mary Boykin Chesnut watched from a roof and swooned, sitting on a chimney and setting her dress on fire. Her husband was in a boat carrying messages to and from Anderson and Beauregard. On April 15, Louis Trezevant Wigfall accepted Anderson's surrender. No one had been injured in the two days of cannon fire. (Courtesy of the Library of Congress.)

Christopher Gustavus Memminger (1803–1888)
Memminger grew up in the Charleston Orphanage until Thomas Bennet, a prominent lawyer and later governor, took him under his care. He graduated from South Carolina College and then studied law. He served as the secretary of the treasury for the Confederacy until his resignation in 1864. After the war, he set up the public school system for both African Americans and white children in Charleston. He married Mary Withers Wilkinson. (Courtesy of the Charleston County Public Library.)

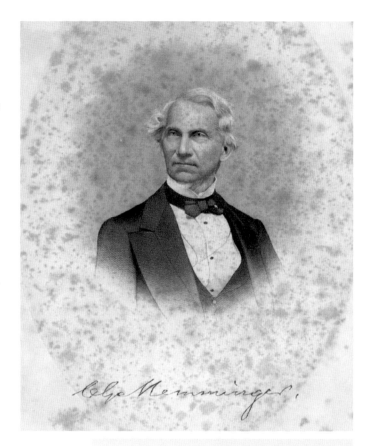

Stephen Dill Lee (1833–1908)
Stephen Lee was born in Charleston and graduated from West Point in 1854. He reached the rank of lieutenant in the US Army before resigning when South Carolina seceded. He delivered the demand for surrender to Major Anderson at Fort Sumter. He fought at Antietam and Second Bulls Run and many others, getting wounded twice and rising to the rank of lieutenant general. He was taken prisoner at Vicksburg when it fell. This statue stands in Vicksburg in his honor. He surrendered with Johnston's forces. He married Regina Harrison and had one son. (Courtesy of the Library of Congress, Prints and Photographs Division, Detroit Publishing Company Collection.)

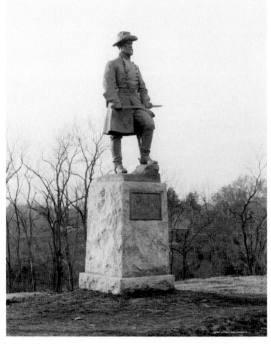

46

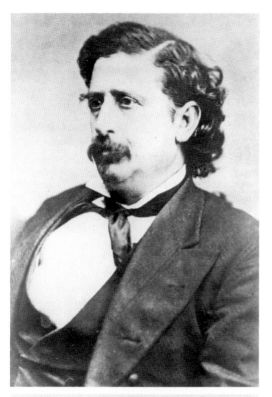

Edwin Warren Moise (1832–1902)
Born in Charleston, Moise was a member of Kahal Kadosh Beth Elohim Synagogue before moving to Georgia to work and read law with his uncle. He opposed secession but, when the war started, he organized a cavalry company and fought with Wade Hampton. He was captain of the Moise Rangers, which became Company A of the 7th Confederate Cavalry. When Wade Hampton became governor in 1876, Moise became adjutant general. He married Esther Lyon, and they had 13 children. (Courtesy of the Library of Congress.)

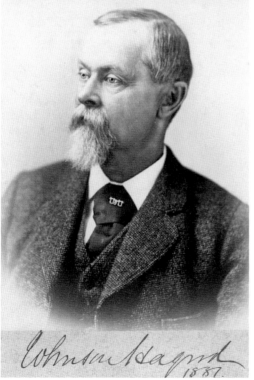

Johnson Hagood (1829–1898)
Johnson Hagood was at the top of his class when he graduated from The Citadel in 1847. He was admitted to the bar but returned to his plantation in Barnwell. He fought in many battles with the Confederate army and attained the rank of brigadier general. In 1876, he became comptroller general of the state and successfully sued the federal government for reparations for its use of The Citadel during reconstruction. He was elected governor, and The Citadel reopened in 1882. The Citadel's football stadium is named after him. He married Eloise Butler, and they had one son. (Courtesy of the South Carolina Department of Archives and History.)

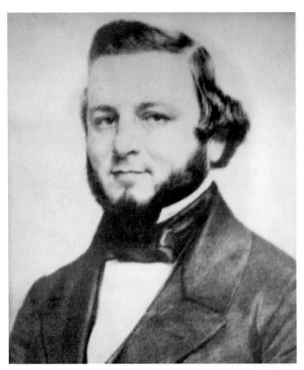

Judah Philip Benjamin (1811–1884)
Judah's family immigrated to the United States from St. Croix in 1813, coming to Charleston in 1822. In Charleston, his father, with Isaac Harby and others, founded the Reformed Society of Israelites, breaking from Kahal Kodesh Beth Elohim Synagogue. Benjamin attended Yale College and read for the law in New Orleans, being admitted to the Louisiana bar in 1833. He was a US senator who resigned to serve the Confederacy. He was appointed attorney general, then secretary of war, and finally secretary of state. One historian called him the "brains of the Confederacy." He married Natalie Bauche de St. Martin, and they had one daughter. (Courtesy of the Library of Congress.)

William Aiken Jr. (1806–1887)
Born in Charleston as the only child of William Aiken, a prominent merchant and planter, William became a prosperous rice and cotton planter who owned 878 slaves and a large plantation on Edisto Island. He served as governor from 1844 to 1846 and then in the US House of Representatives from 1851 to 1857. He opposed nullification and secession but gave money to support the Confederacy. His house was donated to the Charleston Museum in 1977 and is now owned by the Historic Charleston Foundation and is open for tours. He married Harriet Lowndes, and they had one daughter, Henrietta, who married Maj. A.B. Rhett and had four children. (Courtesy of the Library of Congress.)

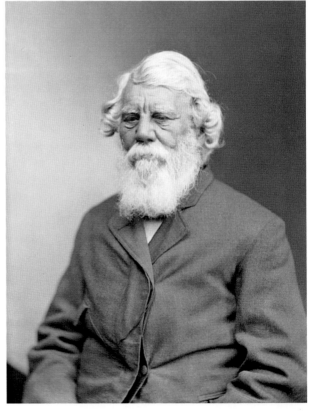

48

Robert E. Lee (1807–1870)

On the night of December 11, 1861, Robert E. Lee was staying at the Mills Hotel when fire swept through Charleston. It began on East Bay Street at Hasell Street and cut a path of destruction all the way across town to the Cathedral of St. John and St. Finbar on Broad Street. Lee saved the hotel by telling people to wet blankets and hang them from the windows. There was a strong wind, and before it could be put out, the fire had destroyed Institute Hall, St. Andrews Hall, the Circular Church, the cathedral, and all of the homes and businesses in between. The Civil War prevented recovery for many years. Robert E. Lee went on to become the hero of the Civil War. (Courtesy of the Library of Congress.)

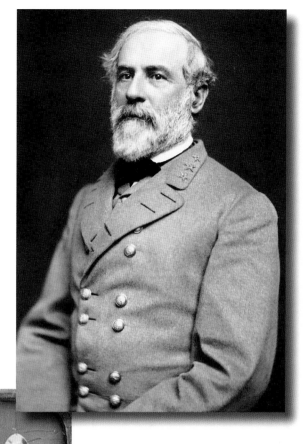

Firefighters

Charleston had a history of fires and organized its first fire company in 1784. This 1865 photograph shows the foremen of the Phoenix Fire Company and the Mechanics Fire Company and one unidentified fireman. The first steam engine was purchased after the 1861 fire, and a hook and ladder company was formed. (Courtesy of the Library of Congress.)

49

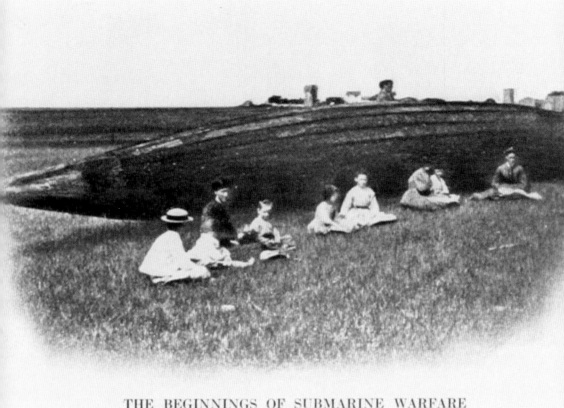

THE BEGINNINGS OF SUBMARINE WARFARE

A CONFEDERATE PHOTOGRAPH OF '64—THE FIRST "DAVID," FIGURING IN
HEROIC EXPLOIT

CSS David

Theodore Stoney conceived of a semisubmersible torpedo boat. Working with Dr. St. Julien Ravenel, they designed the boat and built it at Ravenel's plantation in 1863. It was powered by an engine using anthracite coal because it burned without smoke and rode so low in the water that only the surface and boiler stack showed. On October 5, 1863, under the command of Lt. William T. Glassell, the *David* attacked the USS *New Ironsides*. The spar torpedo exploded under its target, damaging but not sinking the *Ironsides*. Two crewmen were captured, one died of gunshot wounds, one had his legs broken, and one had contusions. The success of the CSS *David* led to the building of 20 more torpedo boats under David Chenoweth Ebaugh. (*The Photographic History of the Civil War,* 1911.)

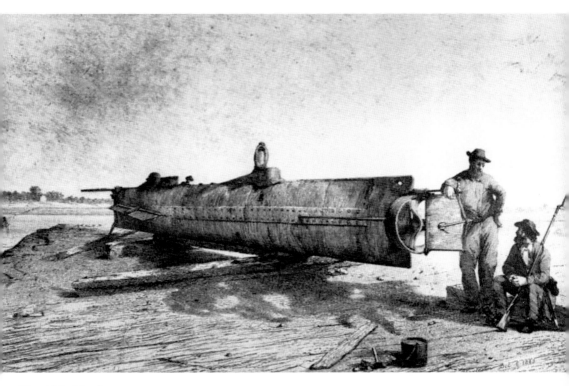

The *H.L. Hunley*

Horace Lawson Hunley designed and built the first submarine in Mobile, Alabama, launching it in July 1863. It was shipped to Charleston in August and turned over to the Confederate army. It sank on its first training run, and five men were lost. Hunley himself was lost when he boarded it with seven volunteers for its second trial. On February 17, 1864, under the command of George E. Dixon, it attacked and sank the USS *Housatonic*, which was part of the Union blockade of Charleston Harbor. The submarine sank, and eight more men were lost. The vessel—about 40 feet long with a circumference of a little over four feet—was powered with a hand crank operated by the crew. It was never commissioned into the Confederate Navy, thus it has no CSS in front of its name. The wreckage was found in 1970 by E. Lee Spence, and its location put in the National Register of Historic Places in 1978. It was rediscovered in 1995, and Sen. Glenn McConnell oversaw the recovery of the submarine and creation of the Hunley Museum. (US Navy History and Heritage Command.)

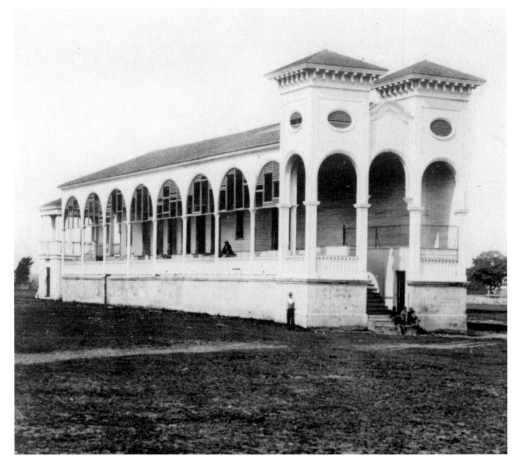

The Jockey Club

Horse racing was one of the favorite pastimes of Charleston from the early 1700s. The Jockey Club was formed that oversaw the races, moving to the Washington Course in 1792. Dinners, parties, and balls were held every February around the races. These involved people of all levels of Charleston society, and people from all over the country came to show off their thoroughbreds and bargain to improve their stock. The grandstand was erected in 1836. The groomsmen and jockeys, most of whom were slaves, were as well-known and respected as the horses and their owners. Silver cups and salvers were awarded as prizes and graced sideboards for decades. John B. Irving wrote a history of the Jockey Club in 1857, which can be read online. It includes the genealogy of many of the winning horses. Attempts were made to continue the tradition after the Civil War, but the club disbanded in 1882. (Courtesy of the Library of Congress.)

The First Memorial Day (OPPOSITE PAGE, ABOVE)

During the Civil War, the racecourse was used by the Confederates to house prisoners of war. There was no shelter, and at least 257 men died and were buried in unmarked graves. Together teachers, missionaries, and freed African Americans landscaped the area and built an enclosure with an arch that read "Martyrs of the Race Course." The bones were dug up and buried respectfully with markers. On May 1, 1865, 10,000 people gathered to honor and put flowers on the graves of those who died there. The *New York Tribune* and other Northern papers wrote about the event. (Courtesy of the Library of Congress.)

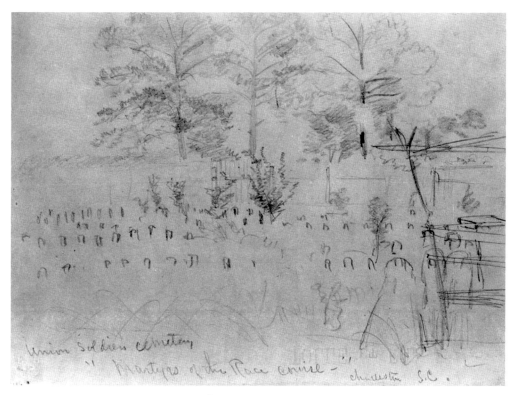

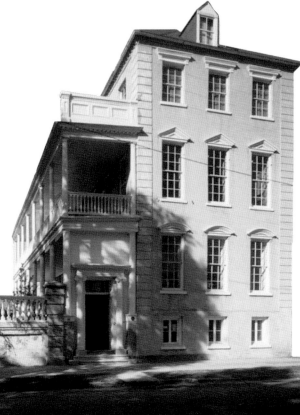

Moses Cohen Mordecai (1804–1888)

This is the house bought by Moses Mordecai in 1837 from Dr. Jean Earnest Poyas. Mordecai served in the state Senate and operated a steamship line before the war. It was his flagship, the *Isabel*, that removed Robert Anderson from Fort Sumter when he surrendered. During the war, he became a blockade-runner. After the war, he moved to Baltimore and recouped his fortune and, in 1870, he financed bringing home the bodies of all the South Carolina men who fell at Gettysburg. He married Isabel Rebecca Lyons, and they had eight children. (Courtesy of the Library of Congress.)

53

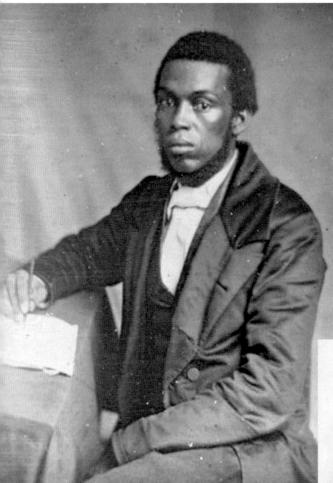

James Skivring Smith
(c. 1825–1892)

James Smith was born in Charleston of free African American parents who immigrated to Liberia in 1833. At the suggestion of a white missionary doctor, Smith returned to the United States to study medicine, first at the Vermont College of Medicine and then the Berkshire Medical Center, making him the first African American to graduate. He returned to Liberia where he was made secretary of state. In a political upheaval, he was president of Liberia for two months in 1871. He practiced medicine and served as superintendent of Grand Bassa County. (Courtesy of the Library of Congress.)

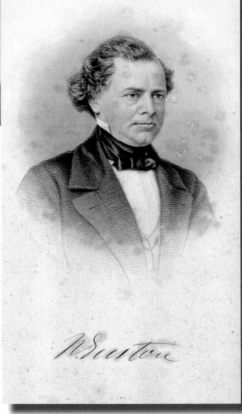

William Enston (d. 1860)

William Enston was an immigrant furniture-maker and merchant from England. He died in 1860, leaving a million dollars for the creation of a home for the indigent elderly. His will stipulated that the people should be between 45 and 75 years old, of good character, and not suffer from lunacy. The Civil War intervened and reduced the fortune, but the cottages were built in 1887. It is now run by the Housing Authority of Charleston. (Charleston County Public Library.)

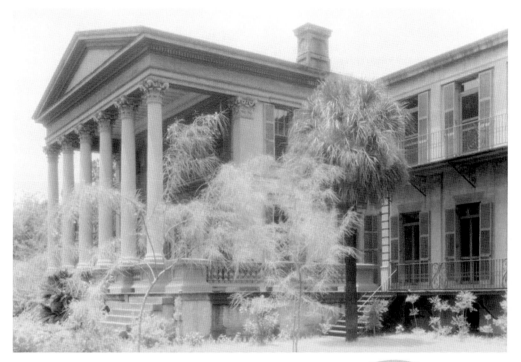

Isaac Jenkins Mikell (1809–1881)

Isaac Jenkins Mikell was a cotton planter on Edisto Island who inherited the Peters Point Plantation from his father in 1838. He built this Charleston house for his third wife, Mary Martha Pope, around 1851. When Union forces occupied Edisto, his family escaped to this house in a harrowing boat trip using 12 oarsmen. Except for the grandfather of the present Isaac Jenkins Mikell, Pinckney Venning Mikell, Peters Point has been occupied by an Isaac Jenkins Mikell for 175 years. There are two more Isaac Jenkins generations awaiting their turn. The Charleston County Library was housed here until the 1950s. (Courtesy of the Library of Congress.)

William Ashmead Courtenay (1831–1908)

William Courtenay was a true war hero. He enlisted as a private fighting in Kershaw's Brigade at First Bull Run, Fredericksburg, Gettysburg, and Chickamauga, becoming a captain. He was captured and spent the last year of the war imprisoned at Johnson's Island, Ohio. He served as mayor of Charleston from 1879 to 1887, facing cyclone damage in 1885 and the earthquake in 1886. Under his leadership, the city was restored in just 14 months. He formed the Town of Newry, where he operated a cotton mill. He married Julia Anna Francis, and they had six children. (Courtesy of the Charleston County Public Library.)

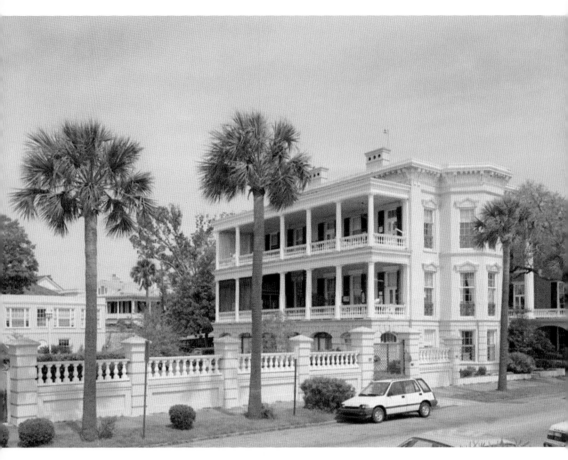

Dr. St. Julien Ravenel (1819–1882) and Harriott Horry Rutledge Ravenel (1832–1912)
Dr. Ravenel was a medical doctor and a chemist whose work with lime and phosphates led to their effective use as fertilizers and increased the production of South Carolina's farmland. The resulting phosphate industry became an important source of revenue after the Civil War. During the war, Ravenel was in charge of the Confederate hospitals in the state and designed the *David* (see page 50). It was Harriott, his wife, who named the *David* for the David of David and Goliath. She wrote the book *Charleston: The Place and the People*, which was first published in 1906. This book chronicles the daily life of the people from the earliest days of settlement through the Revolutionary War, explaining their politics and telling their stories. She also wrote books about Eliza Pinckney and William Lowndes. The couple had eight children. (Courtesy of the Library of Congress.)

Mary Boykin Chesnut (1823–1886)

Mary Boykin Miller Chesnut kept a diary throughout the Civil War. Her husband, James Chesnut Jr., was serving in the US Senate when South Carolina seceded and was the first to resign his seat. She accompanied him to Montgomery when the Confederacy was being established and was party to all of the associated characters, machinations, and politics. She was in Charleston for the firing on Fort Sumter while her husband rowed messages between Beauregard and Anderson. Her husband was an aide to Jefferson Davis, and they lived across the street from the Confederate White House in Richmond. Early in 1864, her husband was sent to Charleston as a brigadier general to aid in recruitment but he was actually sent to mend the rifts between South Carolina and the Confederacy. Because of her husband's position, Mary was in the most strategic places at the most volatile times. Through all of it, she wrote in her journals with a keen eye and a wicked wit. She knew the intimate details of the lives of the people who were making monumental decisions affecting the lives of thousands. She hated slavery and found life on the plantation at Mulberry frivolous and shallow. She enjoyed the mental stimulation of parlor discussions with politically powerful people. Her honest unvarnished opinions could be written in her journals when politeness would not allow them to be expressed in the parlor. Her writings have been published in several versions. *Mary Chesnut's Civil War*, edited by C. Vann Woodward, was published in 1981 and received the Pulitzer Prize for history. After the war, she and her husband faced the reduced circumstances everyone else did. Her final years were spent in Camden running a dairy to support herself and assorted relatives who lived with her. She never had any children. (Portrait by Samuel Stillman Osgood; courtesy of the National Portrait Gallery.)

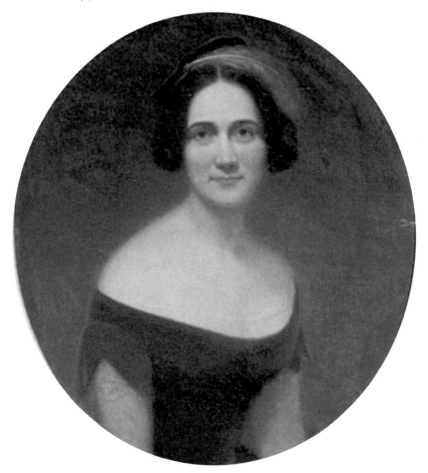

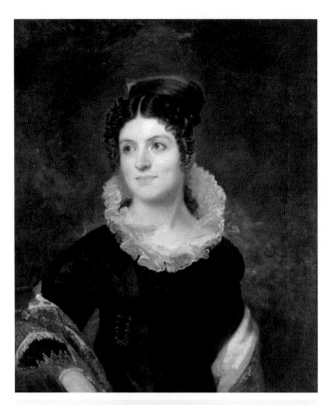

Caroline Gilman
(1794–1888)

Caroline and her husband, Samuel, moved to Charleston from Massachusetts soon after they were married in 1819. He was made minster of the Unitarian Church and stayed there for almost 40 years. The birth and death of her sixth child in 1831 was the impetus for her writing and seeking publication. She published *Recollections of a Housekeeper* in 1834, *Recollections of a Southern Matron* in 1838, and *Love's Progress* in 1840. Her seventh child was born and died in 1840, and she stopped writing. She remained in South Carolina through the Civil War. (Portrait by John Wesley Jarvis; courtesy of the Harvard University Portrait Collection.)

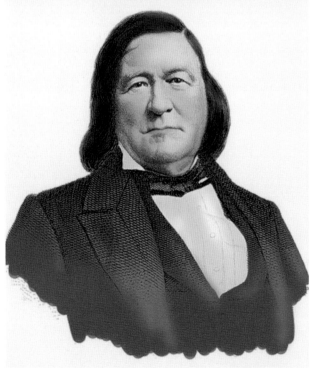

James Louis Pettigru
(1785–1863)

"South Carolina is too small for a Republic and too large for an insane asylum." This quote from James Louis Pettigru is still apropos and still quoted. He was a lawyer and the attorney general and opposed the nullifiers and the secessionists and remained a unionist throughout the Civil War. His epitaph in St. Michael's was read by Woodrow Wilson to the convention meeting to form the League of Nations. He married Jane Postell and had five children, but only two girls lived to adulthood. (Engraving by A.H. Ritchie; courtesy of *Charleston City Paper*.)

George Alfred Trenholm (1807–1876)

Many believe Rhett Butler in *Gone with the Wind* was patterned after this man. George Alfred Trenholm had to leave school because of the death of his father and went to work for John Fraser, a major cotton broker. By 1860, he was one of the wealthiest men in the United States. During the Civil War, the Fraser Company financed a fleet of blockade-runners and operated as the Confederacy's overseas banker. In July 1864, Trenholm succeeded Memminger as the secretary of the treasury. He married Anna Helen Holmes, and they had two children. (Engraving from *The Rise and Fall of the Confederate Government, Volume II*, 1881.)

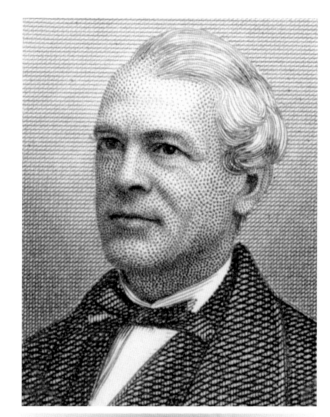

Francis Peyre Porcher (1825–1895)

Dr. F. Peyre Porcher published *Resources of the Southern Fields and Forests* in 1863. He had been asked to make the information available to the Army because medicines were not getting through the blockade for the military or civilians. It was the first extensive study of indigenous plants and their medicinal uses. Before the war, he and Dr. Julian Chisolm opened a hospital for slaves. He taught at the Medical College and represented the United States at medical conferences abroad. Virginia Leigh was his first wife, and then he married Miss Ward. (Courtesy of the South Caroliniana Library.)

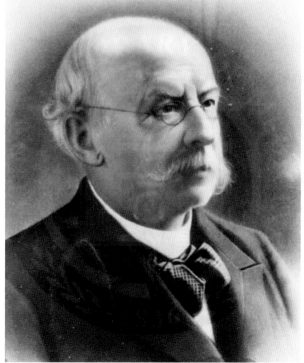

Wade Hampton (1818–1902)

Wade Hampton was born in the William Rhett House in Charleston and was the son of one of the wealthiest planters in the South. He graduated from South Carolina College and studied law but never practiced it. He opposed secession and questioned the viability of slavery but resigned the state senate to enlist when the war came. He organized a unit called Hampton's Legion, providing all of the weaponry for six infantry companies, four cavalry companies, and one battery of artillery. Fighting with Lee, these men were in every major battle in Northern Virginia. He was wounded three times and continued to lead his men and was made a brigadier general. He came home from the war to find his plantation home outside of Columbia burned, his finances depleted, and his state occupied by enemy troops. Hampton and his supporters met at Grace Piexotto's brothel on Fulton Street in Charleston, where they planned to take control of the state from the Radical Republicans. His supporters were called Red Shirts, and their tactics were sometimes questionable. The election of 1876 was said to be the bloodiest political contest in the history of the state. Both sides claimed victory. Two legislatures met, and Chamberlain took the oath of office and had Hampton barred from the capital until the state supreme court gave the win to Hampton. President Hayes withdrew federal troops when the election was settled, ending the hated occupation. As governor, Hampton did all in his power to right the wrongs done by the Radical Republicans who had held power since 1865. He favored voting rights for freedmen. Reelected to the governor's office and the Senate, he chose to serve as a senator. Most historians count Hampton's election as the end of reconstruction. Hampton married Frances Smith Preston and had five children. When she died, he married Mary Singleton McDuffie, with whom he had four more children. (Courtesy of the Library of Congress.)

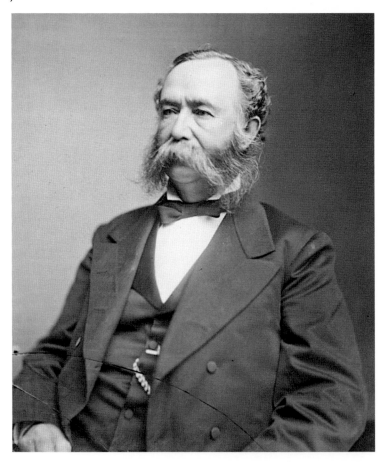

Andrew Buist Murray (1844–1928)

Andrew Buist Murray entered the Charleston Orphan House in 1857 when his father died. His mother had died some time earlier. He was adopted by Washington Jefferson Bennett, the owner of a rice and lumber business. Andrew went into that business with Bennett's two sons, and they made a fortune. His philanthropy included Murray Boulevard, Murray Vocational School, and paving the racetrack around Hampton Park, which he named for his wife, Mary Hayes Bennett. The Charleston Orphan House, The Citadel, and the College of Charleston also benefitted from his bounty. (Courtesy of the Charleston County Public Library.)

William Gilmore Simms (1806–1870)

Simms's mother died when he was born, and his father ran off to fight Indians, so he was raised by his grandmother in Charleston. He read for the law and passed the bar but instead became the writer, editor, and part owner of the *City Gazette*. His writings included poetry, biography, history, and novels. Edgar Allan Poe declared him to be the greatest novelist in America. His *History of South Carolina* was the textbook in schools for over 100 years. He wrote eight novels set in Revolutionary South Carolina and 10 set on the Southern frontier. He married Ann Malcolm Giles, and they had one daughter. When Ann died, he married Chevillette Eliza Roach, and they had 16 children—though only 6 survived childhood. (Courtesy of the Library of Congress.)

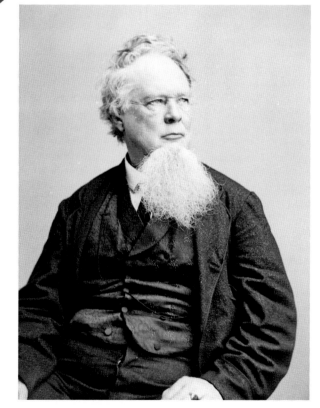

61

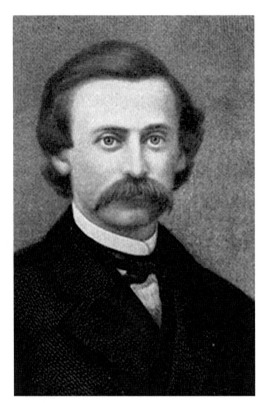

Henry Timrod (1828–1867)

Henry Timrod has been called the poet laureate of the Confederacy. Bob Dylan's verses have been compared to Timrod's poems. He read law but made a living teaching. He volunteered for the Army but was sent home because of his health. He returned to the war as a correspondent for the *Charleston Mercury* but again had to come home. He was editor of the *South Carolinian* newspaper in Columbia when Sherman burned his offices. His poem "Carolina" is the verse of the state anthem. He married Kate Godwin Cannon, and they had one son who died in infancy. (From *Poems of Henry Timrod: Memorial Edition.*)

Paul Hamilton Hayne (1830–1886)

Paul Hayne collected and had published the poems of his friend Henry Timrod after Timrod died. When Hayne's father died, he and his mother moved in with his uncle Robert Y. Hayne (see page 39). He graduated from the College of Charleston and read law but volunteered for the Army. He was sent home because of his health. He moved to Grovetown, Georgia, in 1862 when the federal bombardment destroyed everything he owned. In partnership with William Gilmore Simms, he founded *Russell's Magazine*, which he edited. He published a collection of his poems in 1882 and became nationally known. (Courtesy of the Hayne family.)

CHAPTER THREE

Preservation, Rejuvenation, and Celebration
1900–2012

Condé Nast Traveler magazine named Charleston the number one tourist destination in the world in 2012 and in 2013 named the Wentworth Mansion as the number one hotel in the United States. *Travel + Leisure* magazine named Charleston the number one city in the United States and Canada and number seven in the world in 2013 after saying Charleston had the most attractive people in 2010. It has also been named the friendliest city and the most mannerly. In 2012, the Milken Institute put it in their top 10 of "Best Performing Cities" in 2012 based on job growth. The credit for all of this recognition goes to the people visitors meet, the tour guides, carriage drivers, vendors in the Market, taxi drivers, pedicab operators, concierges, luggage handlers, and valets. The chefs and waitstaff in our restaurants play their part, as well as the organizations that plan house tours and special events. The people in this chapter have all of the ones who came before to thank for preserving the city and for teaching them how to live. Charleston people figured out how to survive intolerable inconveniences of occupation by enemy troops with grace and fortitude. They took that into every endeavor. The Great Depression was not as noticeable to people who had twice before survived total economic upheaval. The well educated and well mannered did not lose their upbringing when they lost their fortunes. Part of their upbringing was accepting responsibility to make life pleasant for the people around them and to help the less fortunate in whatever way they could. They grew up with a moral obligation to give back and contribute to the whole community. The wars of the 20th century were fought in other places. Enemy troops did not walk the streets of the city. The Naval Shipyard provided good jobs that paid well. The Civil Rights Movement addressed some of the problems created by the slave system. The middle class thrived, and prosperity encouraged artistic and cultural enterprises. Writers, artists, and musicians flourished. Yates Snowden called Charleston the Holy City because of the reverence Charlestonians feel for their home. The writers write about it, the artists paint it, and the scholars study and write its history. People name their children for its streets. (That's a joke. Children are named for their ancestors, as are the streets.) John Locke's independent free people have done well.

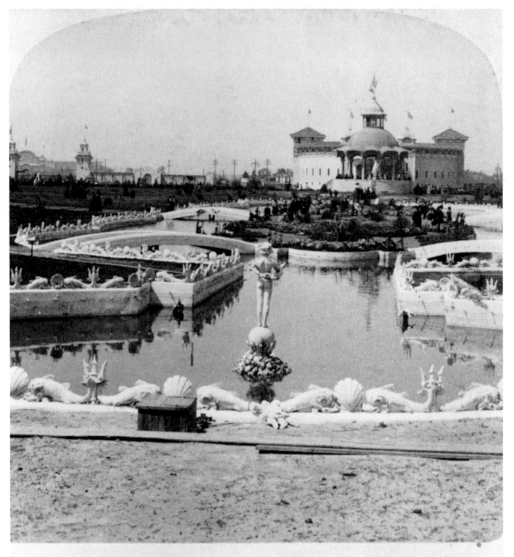

Beautiful Grounds and Buildings of the Inter-State and West Indian Exposition, Charleston, S. C. Copyright 1902 by Underwood & Underwood.

South Carolina Inter-State and West Indian Exposition (1901–1902)

In an effort to stimulate the use of Charleston's port, the Charleston Exposition Company was formed in 1900. Frederick C. Wagener was made the president and donated the use of his farm that adjoined the old Washington Racecourse to make a display area of 250 acres. Twenty states and five countries of the Caribbean built exhibits. There was a cotton palace, a commerce palace, an agricultural palace, and exhibits honoring blacks, women, and Eskimos. Pres. Teddy Roosevelt visited and spoke, and 675,000 people attended. It served as a morale boost and point of pride for the Charleston residents. When it was over, half of the land became Hampton Park and the other half became the new campus for The Citadel. (Courtesy of the Library of Congress.)

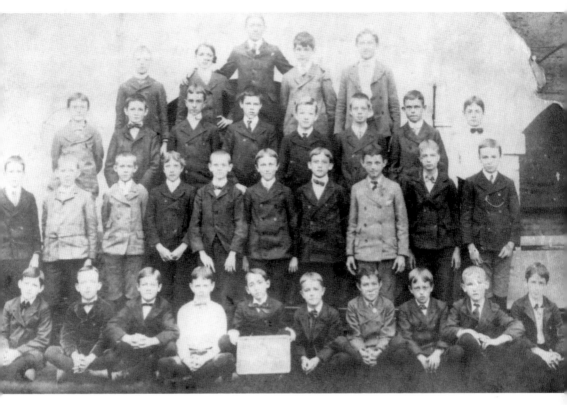

Bennett School (1902–1903)

Identified only by last name with some exceptions, from left to right are (first row) Glasser, Sanders, Brig. Gen. Barnwell Rhett Legge, Cohen, Jacobson, Sam Lockwood (died in an automobile accident in 1914), McGrath, Edward B. Hollings, Doscher, Elias, and Schiadaressi (Ted Schiadaressi was the owner of the Folly Beach Pier, which showcased Guy Lombardo, Harry James, the Inkspots, and other nationally known entertainers of the 1930s and 1940s); (second row) Pitcher, Guy Alexander Huguelet (founder and president of Southeastern Greyhound Bus Lines), Erickson, Hollings, Meyer, Robert Reynolds, Wigfall, Epstein, Stehmeyer, and Veronce; (third row) Wagner, Price, Robert Lockwood Brown, Pregnall, George W. Johnson (the photographer), Ferara, and Sidney J. Cohen (graduated first in his class in 1915 and died at 24 after getting a master's degree); (fourth row) Ernest Edward Wehman Jr. (mayor of Charleston from 1944 to 1947), Van K. Reynolds Stowbridge, Grimke, and Clauss. (Courtesy of Eugene Johnson DeVeaux.)

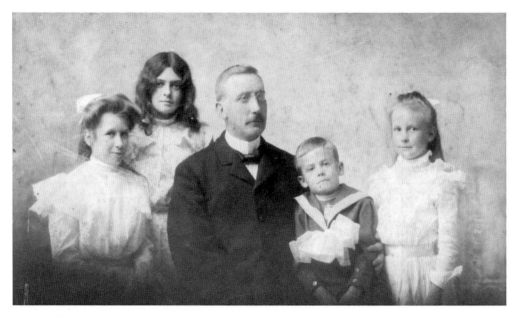

Robert Goodwyn Rhett (1862–1939)

Robert Goodwin Rhett was a lawyer, businessman, and banker who served as president of South Carolina Loan and Trust Company, Peoples National Bank, Land Pebble Phosphate Company, and four building and loan associations. He was treasurer and director of a railroad company and director of several other banks and businesses. He was elected mayor in 1903 and 1907. He wrote *Charleston: An Epic of Carolina*. He married Helen Smith Whaley, and they had four children. Pictured here are, from left to right, Helen Whaley, Peggy Cuthbert, Robert Goodwyn, Robert Goodwyn (son), and Margaret Goodwyn Rhett. His second wife was Blanche Salley. (Courtesy of Reid Simons Fulton.)

William Deas (dates unknown)

William Deas was the Rhetts' butler. He was in charge of the dinner to be served when President Taft came to visit. It happened that he had a crab with an egg pouch so he added the roe to the crab soup and dubbed it she-crab Soup. It has been a favorite delicacy in Charleston ever since. When Goodwyn Rhett died, William went to work in the kitchen of Everett's Restaurant, which became famous for his she-crab soup. (Portrait by N.C. Meares; courtesy of Everett Presson.)

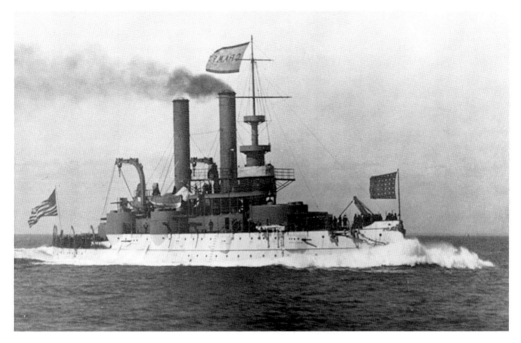

Edward Floyd (1850–1923)

Edward Floyd was a boilermaker on the USS *Iowa* when, on January 25, 1905, the manhole plate of Boiler D blew out. Floyd was awarded the Congressional Medal of Honor for extraordinary heroism for the actions he took at that time, saving the lives of crewmen and the ship itself. He was married to Ella McClellon. He is buried in the St. Lawrence Cemetery in Charleston. (Courtesy of the Library of Congress.)

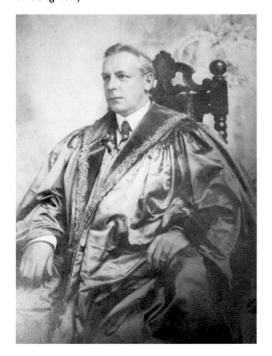

Judge Richard Smith Whaley (1874–1951)

Before he began his legal career, Richard Whaley was the first football coach at the University of South Carolina, leading his team to win the first Carolina-Clemson game. He served in the state legislature before being elected to the US Congress where he served from 1913 to 1921. He was appointed a commissioner on the United States Court of Claims and moved through that court as judge and then as chief justice. He remained a bachelor until 1947, when he married Rosa McWane Barksdale. (Courtesy of Beverly Stoney Johnson.)

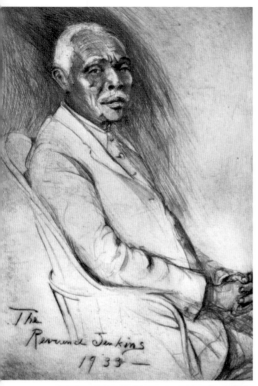

Daniel Joseph Jenkins (1862–1937)

Daniel Jenkins was born a slave in Barnwell and moved to Charleston after the Civil War, starting a firewood business and becoming a minister. He found four boys living in a boxcar one cold winter morning and conceived the idea for an orphanage. The state chartered the orphanage in 1892, and it moved into the Old Marine Hospital Building, which was being used as a school for African American children. Reverend Jenkins bragged in a 1935 *Time* magazine article that fewer than 10 children of the hundreds who came under his care had ended up in prison. (*Prints and Impressions of Charleston*, Elizabeth O'Neill Verner with permission of David Hamilton.)

Jenkins Orphanage (1895–1937)

This building was designed by Robert Mills (see page 37) as the Marine Hospital and was built in 1833. During the war, it was a hospital for Confederate soldiers. The orphanage was housed here from 1892 until 1937, when it was moved to a larger campus in North Charleston; the building was renamed the Jenkins Institute for Children. In 1939, the building was remodeled as the Housing Authority of Charleston. It was designated a National Historic Landmark in 1973. (Courtesy of the Library of Congress.)

JENKIN'S ORPHANAGE BAND PLAYING AT THE Y. M. C. A. BUILDING, ST. PETERSBURG, FLA. THE SUNSHINE CITY 44

Jenkins Orphanage Band

Looking for a way to raise money to support his orphanage, Reverend Jenkins hired "Hatsie" Logan and Francis Eugene Mikell to teach the boys music and form a band. In just two years, dressed in old Citadel uniforms and using donated instruments, the band was earning money and traveling the country giving concerts. They marched in inaugural parades and made a European tour. Band alumni became jazz greats. There is a newsreel movie online made of the band in 1928. (Postcard published by the Hartman Card Co., Tampa, Florida.)

Jabbo Smith (1908–1991)

Smith moved to the orphanage when he was six; however, his mother worked there. He learned to play the trumpet and traveled with the bands until he ran away when he was 16 years old. His career included playing with Duke Ellington, Fats Waller, and Roy Eldridge, who claimed that Jabbo outplayed him in 1930. He made records and led a group at the 1939 World's Fair in New York. He discovered Sarah Vaughn and urged her to enter a talent contest at the Apollo, which she won. He is in the Coastal Jazz Hall of Fame. (Courtesy of South Caroliniana Library, University of South Carolina, Columbia.)

George W. Johnson (1858–1934)

George Johnson constructed his first camera and used it to document his life in Charleston from the late 1890s until his death. His photographs cover the daily life of chimney sweepers, shoeshine boys, houses, public buildings, and politicians. Using a "magic lantern" and glass slides, he projected slide shows on a sheet hung from his building, free to the public on special occasions. His photographs chronicle events and people that would have been lost to history without him. (Courtesy of Eugene Johnson DeVeaux.)

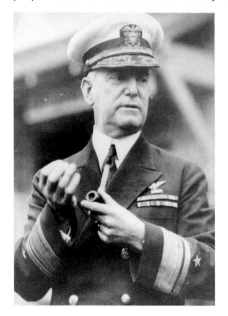

Rear Adm. William Adger Moffet (1869–1933)

Admiral Moffet was born in Charleston and graduated from the US Naval Academy. He served on the USS *Charleston* in Guam and Manila. He was captain of the USS *Chester* in Veracruz, Mexico, where he was awarded the Medal of Honor. During World War I, he established an aviation training program that led to the creation of the Navy's Bureau of Aeronautics. He was known as the "Air Admiral" for his fostering of the Naval Air Corps and its aircraft carriers. He also advocated dirigibles and died in the crash of the USS *Akron*. He married Jeanette Whitten, and they had three sons. (US Navy History and Heritage.)

Susan Pringle Frost (1873–1969)

Susan was the daughter of Rebecca Brewton Pringle of the Miles Brewton/Pringle house and Francis LeJau Frost of the rice plantations and fertilizer business in the economic upheaval following the Civil War. She became a court stenographer. She was the first president of the Charleston Equal Suffrage League. She bought and renovated old Charleston houses, including Rainbow Row (pictured), and with assistance managed to keep the Pringle house. In 1920, to save the Joseph Manigault house, she founded what became the Preservation Society. (Photograph by the author.)

Anita Lily Pollitzer (1894–1975)

Anita Pollitzer was born in Charleston and educated at Hunter College and Columbia University, studying art and international law. While in New York, she formed a lifelong friendship with Georgia O'Keefe and introduced her to Alfred Stieglitz. She joined the National Women's Party, the national arm of the suffragette's movement. She rose to serve on its central committee, eventually becoming national chairperson. She toured the country speaking and organizing groups and testified before congress. When the group succeeded, they turned to the Equal Rights amendment and became the World's Women's Party. She was married to Elie Charlier Edson. (Courtesy of the Library of Congress.)

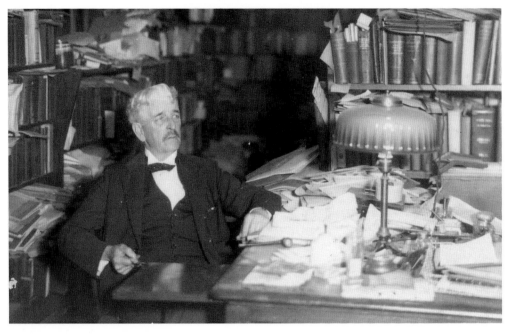

Yates Snowden (1858–1933)

Yates Snowden was born in Charleston and graduated from the College of Charleston. He became a history and political science professor at what became the University of South Carolina. He wrote books and articles on South Carolina history, including a five-volume *History of South Carolina* that was published in 1920 and reissued in 2011. Tom Waring credited Snowden with first calling Charleston the Holy City. His correspondence with John Bennett was published in 1993. He initiated the founding of the Caroliniana Library at the University of South Carolina because he wanted primary historical resource material kept in the state. (Courtesy of the South Caroliniana Library.)

John Bennett (1865–1956)

John Bennett came to Charleston having already published in 1897 a successful book of children's stories called *Master Skylark*. Raised in Ohio, he became fascinated by the African Americans and their Gullah dialect and stories. He collected those stories for 40 years and published them as *Doctor to the Dead* in 1946. He was a founder of the Poetry Society of South Carolina in 1920 and a part of the Charleston Literary Renaissance. Harlan Greene published *Mr. Skylark* about him in 2010. He was married to Susan Dunlap Adger Smythe. (Courtesy of the Charleston County Public Library.)

Alice Ravenel Huger Smith
(1876–1958)

Alice Smith was an artist who experimented with woodblock prints, etchings, and oils but produced her most important works in watercolors. Watercolors lent themselves to the poetic, dreamy quality of her wildlife and landscape paintings. In collaboration with her father, D.E. Huger, she wrote and illustrated *The Dwelling Houses of Charleston* in 1917 and, in another collaboration, *A Carolina Rice Plantation of the Fifties*. She was active in the Poetry Society, Carolina Art Association, and the Preservation Society. She was one of the original members of the Charleston Renaissance. (*Adventures in Green Places* by Herbert Ravenel Sass.)

Beatrice Witte Ravenel
(1870–1956)

Born in Charleston, Beatrice took courses at the Society for the Collegiate Instruction of Women, which became Radcliffe College. She published two books of romantic poetry, *The Arrow of Lightening* and *The Yemassee Lands*, and numerous short stories in *Harper's Magazine*. She also wrote editorials and articles for *The State* newspaper and was part of the Charleston Renaissance. her first husband was Frank Ravenel. After his death, she married Frank's distant relative Samuel Ravenel, with whom she had one daughter, Beatrice St. Julien Ravenel. (Courtesy of the University of North Carolina Press.)

73

Josephine Lyons Scott Pinckney (1895–1957)
Josephine Pinckney was a founder of the Poetry Society and a successful novelist, receiving the Southern Authors Award in 1946 for *Three O'Clock Dinner*. She wrote four other novels and a book of poetry called *Sea Drinking Cities*. She attended Ashley Hall, the College of Charleston, Radcliffe College, and Columbia University. In 1922, she was a founder of the Society for the Preservation of Spirituals, which collected, annotated, and sang the songs sung by African Americans. The group is still active today. Barbara L. Bellows published *A Talent for Living* about her in 2006. (Photograph by Arni, from the dust jacket of *3 O'Clock Dinner*: Viking Press, 1945.)

Edwin Dubose Heyward (1885–1940)
Dubose Heyward was a writer from an early age. He was a founder of the Poetry Society and participated with the Society for the Preservation of Spirituals. He became a best-selling author with his novel *Porgy* in 1926. *Porgy* became a Broadway play with an all African American cast. George Gershwin spent a summer on Folly Beach working with Heyward to create the opera *Porgy and Bess*. *Porgy* is the story of the African American community of Catfish Row—one of the first novels to portray that life with sensitivity and sympathy. Heyward married Dorothy Kuhns, with whom he had one daughter. (Opening scene of *Porgy and Bess* from Decca Album No. 145.)

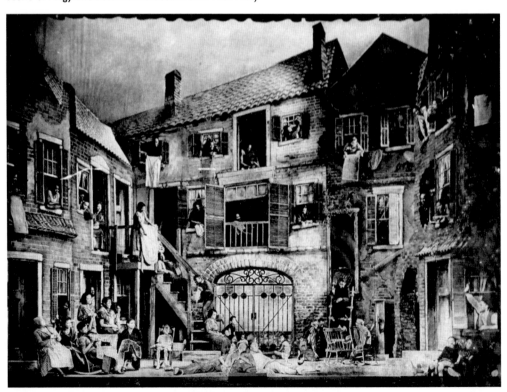

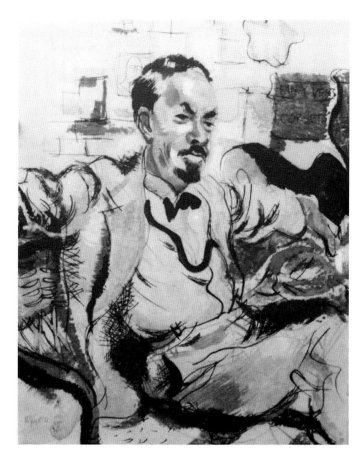

Samuel Gaillard Stoney (1891–1968)

Sam Stoney served on the Board of the South Carolina Historic Society and served as its president twice. He initiated the plantation tours as a fundraiser but also to make the city folk aware of their rural history. He wrote *Plantations of the Low Country* in 1938. Historians wisely trust his margin notes in the books in the library. He wrote *This Is Charleston,* which described, dated, and ranked the buildings of the city in 1944. He taught history at the College of Charleston and was a beloved character who was remembered for pedaling his bicycle around town. (Artist unknown; courtesy of Harriet McDougal Rigney.)

Elizabeth O'Neill Verner (1883–1979)

In rich colorful detail, using pastels on dampened silk mounted on wood—a process she invented, Elizabeth O'Neill Verner depicted the same African Americans that Heyward wrote about in *Porgy*. The subjects of her paintings were the people and houses of Charleston. She wrote and illustrated four books, with *Mellowed by Time* (1941) being the best known. She also illustrated Heyward's *Porgy*. She was a charter member of the Preservation Society and chairman of the Carolina Art Association. The South Carolina Arts Commission gives an award in her name to outstanding artists. She married E. Pettigrew Verner, and they had two children. (Photograph by Steve Yates; courtesy of David Hamilton.)

75

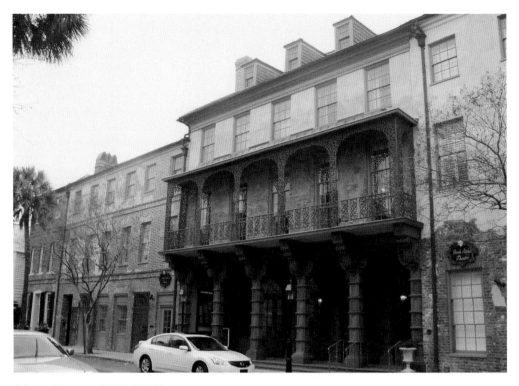

Albert Simons (1890–1980)

Albert Simons was an architect and architectural historian who, with his partner Samuel Lapham, renovated a large number of Charleston's most historic structures, including the Nathaniel Russell House, which they did without pay, and the Dock Street Theatre (pictured). They designed and built the Robert Mills Manor public housing site. He taught art at the College of Charleston and is honored with an award for excellence bearing his name. He wrote *The Early Architecture of Charleston in 1970*. (Photograph by the author.)

Edward Milby Burton (1898–1977)

Pictured here with Jack Leland (left), Milby Burton (right) was the director of the Charleston Museum from 1932 until 1971. He focused the museum on Charleston and its history, both natural and cultural. In 1955, he wrote *Charleston Furniture, 1700–1825,* which is a definitive work on the subject and is still being published. In this book, he said, "The culture of any society is revealed by the material things it needs and the degree of skill which it displays in producing them." He also wrote *South Carolina Silversmiths 1690–1860, The Siege of Charleston 1861–1865, Thomas Elfe Cabinetmaker,* and *Art in South Carolina 1670–1970.* (Courtesy of Cheves Leland.)

Archibald Rutledge
(1883–1973)

Raised on Hampton Plantation in McClellanville, Archibald Rutledge lived in Charleston while attending Porter Military Academy. He graduated from Union College and taught at Mercersburg Academy in Pennsylvania until retiring to Hampton. He wrote over 50 books, including *Home by the River*, *My Colonel and His Lady*, and *Life's Extras*. He was made the first Poet Laureate of South Carolina in 1934. He was married and had three children. He died in the same bed he was born in. Hampton Plantation was given to the state and is a state park. (Photograph by Noble Bretzman, from *Home by the River*, published by Bobbs-Merrill Company, 1941.)

Albert Sottile
(1880–1960)

Born in Sicily, Albert Sottile came to Charleston in the early 1900s to join his brothers who had immigrated earlier. In 1908, he joined with other theater owners to form the Pastime Amusement Company and became its president. He built three theaters and bought two more. The *Gone with the Wind* premiere was held at his Gloria Theatre, with nearly all of its original cast attending. This is the theater given by his family to the College of Charleston. Sottile's house is a landmark at the College of Charleston. He married Mary Ellen Hartnett. At his death, he was survived by his daughter Alberta Long (Mrs. J.C. Long). (Photograph by the author.)

John Charles Long
(1903–1984)

J.C. Long moved to Charleston with his family as a teenager and was a football star at Charleston High School and at the University of South Carolina. He graduated from the University of South Carolina School of Law and brought the first asbestos lawsuit. He was elected to the South Carolina Senate when he was 27 years old. In 1944, he bought the Isle of Palms and formed the Beach Company, which developed the island and properties all over the county. He built the first high-rise residential building and saved the "Four Corners of Law." He married Alberta Sottile, and they had two daughters: Joyce Carolyn, who married Dr. Charles Darby; and Mary Ellen, who married Charles Way. Darby and Way have greatly expanded the business. (*Columbia Metropolitan* magazine; courtesy of The Beach Company.)

Gen. Mark Wayne Clark
(1896–1984)

After graduation from West Point, General Clark saw action in World War I, World War II, and the Korean War, rising to the rank of general and earning a Distinguished Service Cross for extreme bravery. In the Korean War, he was the commander of the United Nations Command and signed the armistice that ended the hostilities. After retiring from the Army, he became the president of The Citadel serving from 1954 until 1965. He remained in Charleston after his retirement and, according to his wishes, was buried on The Citadel campus, the only person to receive that honor. (Courtesy of the Library of Congress.)

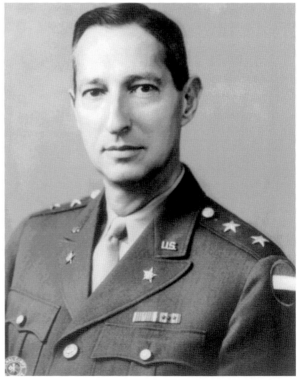

Thomas Sanders McMillan (1888–1939)

Born in Ulmer, Thomas McMillan came to Charleston when he graduated from the University of South Carolina School of Law around 1915. He opened a law office with James B. Heyward but went into politics almost immediately. He was elected to the state House in 1917 and served until he was elected US representative in 1924. He remained in the House of Representatives until he died. He coached The Citadel baseball team as a side job from 1916 to 1919. The photograph shows him doing the Charleston with Sylvia Clavans and Ruth Bennett. The photograph was made in 1926 at the height of the dance's popularity. (Courtesy of the Library of Congress.)

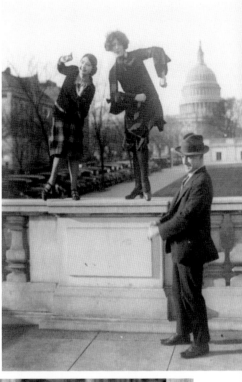

Beauty Queens (1937)

In this photograph, from left to right are Rosemary Reilly (Miss Charleston 1936); Helen Lebby (Miss Charleston 1937); Speaker of the House William Brockman Bankhead, Elizabeth West (Azalea Queen 1937), Dorothy Moore (Azalea Queen 1938), and an unidentified man. From 1934 to 1952, Charleston had an azalea festival every year in the spring. It included a parade, political speeches, and a beauty contest. Speaker Bankhead was the father of the actress Tallulah Bankhead. He represented Alabama. (Courtesy of the Library of Congress.)

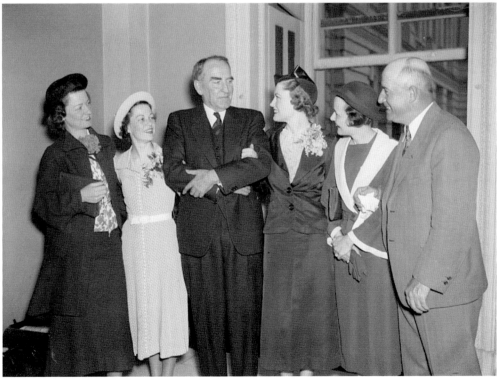

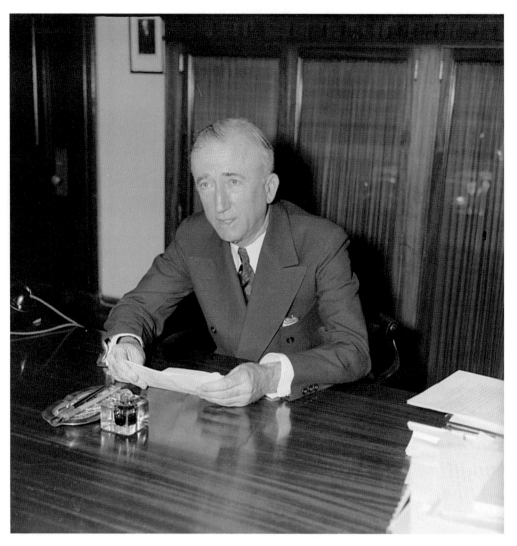

James Francis Byrnes (1882–1972)

James Byrnes's father died soon after he was born, and his mother was a dressmaker in Charleston. He left school when he was 14 years old to work in a law office to become a court stenographer. His cousin Miles B. McSweeney was governor and appointed him to clerk for Judge Robert Aldrich of Aiken. He legally had to be 21 years old to hold this job so he took the birthday of his sister. Without graduating from high school or college, he read for the law and passed the bar in 1903. In 1910, he was elected to the House of Representatives but, in 1924, he tried to run for the Senate and was defeated. He moved to Spartanburg, widening his political base and won the Senate seat in 1930. President Roosevelt appointed him to the Supreme Court in 1941, but he resigned after only a year. He was with Roosevelt at the Yalta Conference negotiating the end of World War II. President Truman made him secretary of state, a role he carried out at the Potsdam Conference and the Paris Peace Conference. He and Truman had differing views, and he resigned in 1947. He returned to South Carolina and became governor in 1951. As governor, he focused on improving education for African Americans. In later years, he switched from the Democratic to the Republican Party. He wrote two books, *Speaking Frankly* and *All in One Lifetime*, with the royalties going to provide scholarships to orphaned children. He married Maude Perkins Busch of Aiken. (Courtesy of the Library of Congress.)

Burnet Rhett Maybank (1899–1954)
Burnet Maybank served in World War I and then became a cotton exporter. He was elected mayor in 1931 and dealt with the effects of the Depression clearing slums, building public housing, and renovating the Dock Street Theatre to provide employment. Maybank became governor in 1938 and continued to work improving education. He was elected to the Senate in 1941 and remained there until he died. He married Elizabeth DeRosset Myers, and they had three children. When she died, he married Mary Roscoe Randolph Pelzer Cecil. (Courtesy of the Library of Congress.)

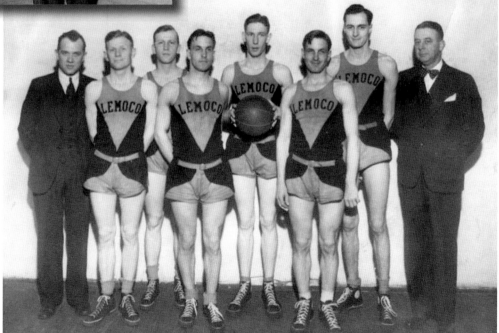

City Champions
Pictured from left to right are Scotty Millar (coach), Archie Lahmeyer, Fred Huneken, Allen Ducker, George Huneken, William J. "Bagger" Schroeder, unidentified, and E.H. McIver (sponsor). Team members not pictured were Allison Siegling, Reid McAllister, and Marty Dubrow. This team won the city championship basketball tournament played at the College of Charleston gym in 1930, 1931, 1933, 1934, 1935, and 1937. The tournaments were sponsored by the YMCA. (Courtesy of Wayne David Lahmeyer.)

Septima Poinsette Clark (1898–1987)

Septima Clark (left) is known as the "Queen Mother" of the American Civil Rights Movement. Teaching on Johns Island with 102 students and one other teacher, she was paid $35 per week, while the teacher in the white school with only three students was paid $85 per week. Teaching at Avery Institute in 1919, she started working with the National Association for the Advancement of Colored People, and they petitioned to have African Americans allowed to be principals of their schools and won. Over time, she received degrees from Benedict College, Columbia University, and a master's from Hampton Institute. She was teaching in the Charleston County School System when a law was passed in 1956 that teachers could not participate in civil rights organizations. She was fired when she refused to leave the National Association for the Advancement of Colored People. Working with the Highlander Folk School, she began teaching adults to read and establishing citizenship schools across the South. Rosa Parks was one of her students. This program came under the Southern Christian Leadership Conference after 1961. When she retired from the SCLC in 1970, she sued the Charleston County Schools for reinstatement of the pension she had lost when she was fired in 1956 and won. She was elected to two terms on the Charleston County School Board. Some of the awards given to Septima Clark were the Martin Luther King Award in 1970, the National Education Association's Race Relations Award in 1976, an honorary doctorate from the College of Charleston in 1978, the Living Legacy Award in 1979, the Order of the Palmetto in 1982, and an American Book Award for her book *Ready From Within* in 1987. She also wrote *Echo in My Soul* in 1962. She is pictured with Rosa Parks at the Highlander School. (Courtesy of the Highlander Research and Education Center.)

Julius Waties Waring (1880–1968)

Judge Waring read for the law and passed the bar in 1902. He served as a city attorney for Charleston from 1933 to 1942, when he was appointed a federal judge by Pres. Franklin Roosevelt. He served as Ellison D. "Cotton Ed" Smith's campaign manager in 1938. In 1948, he became chief justice of the district court and desegregated the courtroom and hired an African American bailiff. In 1950, he heard the first of the five cases that became *Brown vs. the Board of Education* argued by future Supreme Court Justice Thurgood Marshall. In dissenting the majority opinion, he coined the phrase "Separate educational facilities are inherently unequal," which was adopted by the Supreme Court to reverse the findings of the lower court and order integration of the schools in the South. He married his first wife, Annie, in 1913, and they had one daughter who died without heirs. After divorcing his wife of 32 years, he married Elizabeth Avery in 1945. Because of the stance he took on segregation and his divorce, Judge Waring and his wife were excluded from the social life of Charleston, so they moved to New York in 1952. (Courtesy of the Library of Congress.)

Thomas R. Waring (1907–1993)

Tom Waring graduated from the University of the South at Sewanee in 1925 and was awarded an honorary degree from the school in 1961. He began work at the *News and Courier* in 1927, rising to editor in 1951. In 1974, he became editor of the *Evening Post*, where he remained until 1977, when he retired. School integration was an issue, and he steadfastly held that "separate but equal" facilities with a gradual merging was the best approach. He vilified his uncle Judge Waties Waring in the paper. He married Hermina Yates, and they had two children. (Courtesy of Sewanee: The University of the South.)

Frank Bunker Gilbreth Jr. (1911–2001)

Frank Gilbreth moved to Charleston in 1934 to work for the *News and Courier*. He joined the Navy during World War II and earned two Air Medals and a Bronze Star. Returning to the *News and Courier*, he began his "Doing the Charleston" daily column under the name Ashley Cooper. *Cheaper by the Dozen* was a biographical novel he wrote with his sister Ernestine that was made into a movie in 1950. He married Elizabeth Cauthen and had one child. When Elizabeth died, he married Mary Pringle Manigault, with whom he had two children. (Courtesy of Fernando Fernandes.)

Laura Bragg (1881–1978)

Laura Bragg came to Charleston from Massachusetts in 1909 to be a curator at the Charleston Museum. In 1920, she became the first female museum director in the country. Her focus was on the use of the museum for public education, including her innovation of sending "Bragg boxes" to the schools to give children who could not come to the museum a chance to see some of its wonders. She opened the museum to African Americans who had been limited to Saturday afternoon admissions. She also initiated the Charleston Free Library. (Courtesy of the University of South Carolina Press.)

A Bluestocking in Charleston

THE LIFE AND CAREER OF LAURA BRAGG

LOUISE ANDERSON ALLEN

Willard Newman Hirsch (1905–1982)

Willard Hirsch was a sculptor who studied and exhibited in New York before returning home to Charleston in the 1940s. He taught art at the College of Charleston and the Gibbes Museum of Art and worked in his studio on Queen Street. His work can be seen in Washington Park, White Point Gardens, Brookgreen Gardens, and at the Gibbes Museum. He worked in wood, stone, bronze, and terra-cotta. He married Mordenai Raisin and had two children. (WPA photograph.)

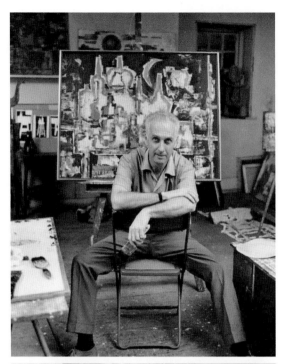

William Melton Halsey (1915–1999)
The Greenville County Museum of Art called Halsey "one of the most important artists in South Carolina's history." He was a modernist and created abstract paintings, collages, sculptures, and assemblages. He taught art at the College of Charleston and, through his students and his own schedule of exhibitions, he promoted contemporary art throughout the South. His portrait of Emmett Robinson is on page 91. He was married to Corrie McCallum, and they had three children. (Courtesy of the Halsey family.)

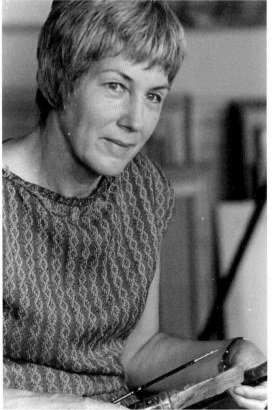

Corrie McCallum (1914–2009)
Born in Sumter, Corrie McCallum studied art at the University of South Carolina and the School of the Museum of Fine Arts in Boston where her husband was also a student. They spent time in Mexico studying art and, in 1942, settled in Charleston. She taught at the Telfair Museum of Art, the Gibbes Museum of Art, College of Charleston, and Newberry College. Her art has won numerous awards. (Courtesy of the Halsey family.)

Albert Sabin (1906–1993)

Albert Sabin was a Russian immigrant who taught and conducted research at the Medical University of South Carolina from 1974 to 1982. He developed the oral polio vaccine that conquered the disease. Jonas Salk had developed a similar vaccine earlier, and there was discussion of which was more effective. The finding was that Sabin's vaccine gave protection longer and prevented the virus from being spread. He also developed vaccines against encephalitis and dengue fever and investigated a link between viruses and certain cancers. (Courtesy of the University of Cincinnati.)

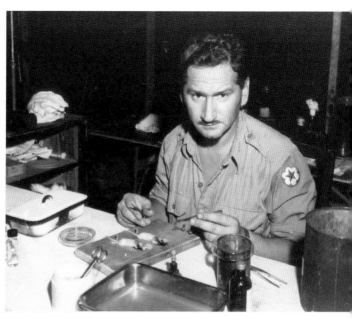

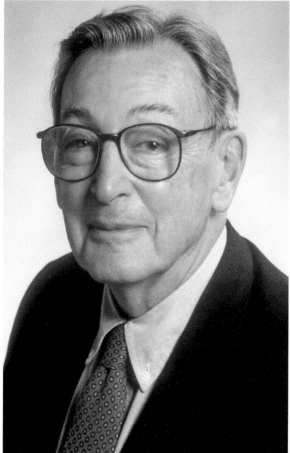

Robert F. Furchgott (1916–2009)

Robert Furchgott was born in Charleston, but his medical research was done at the State University of New York Downstate Medical Center, where he was professor of pharmacology. He was awarded the 1998 Nobel Prize for Medicine for his discovery of a substance that relaxes blood vessels, which led to the development of Viagra. He was married to Lenore Mandelbaum, and they had three daughters. After her death, he married Margaret Gallagher Roth. (Photograph by John A. Zubrovich; courtesy of State University of New York Downstate Medical Center.)

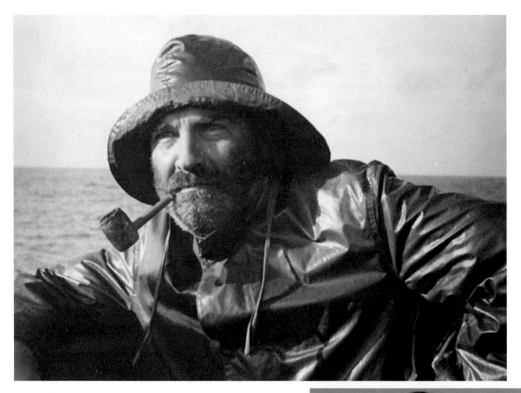

Adm. Creed C. Burlingame (1905–1985)

Admiral Burlingame came to Charleston after a distinguished career in the Navy. He had commanded the submarine USS *Silversides* through most of World War II, earning a presidential citation, two silver stars, and three Navy Crosses. *Destination Tokyo* was a movie made about one of his exploits. The pharmacist's mate had to remove the appendix of one of the crew on one voyage. He taught for 10 years in Charleston County Schools. His wife's name was Doreen, and he had one daughter, Frances June Nelson. (US Navy History and Heritage Command.)

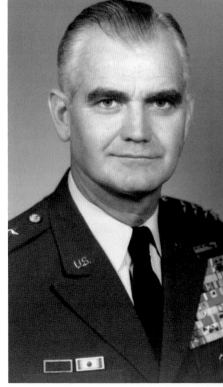

Gen. William Westmoreland (1914–2005)

General Westmoreland was born in Spartanburg, South Carolina, and he attended The Citadel for one year and then transferred to West Point. He achieved the rank of colonel in World War II. In 1964, he became deputy commander of Military Assistance Command, Vietnam, overseeing a troop build up from 16,000 in 1964 to 535,000 in 1968. He came under fire for his Vietnam policy and wrote a biography in 1976 called *A Soldier Reports* giving his views. He retired to Charleston in 1972 and ran for governor in 1974. He married Katherine Stevens Van Deusen, and they had three children. (US Army.)

Emmett Edward Robinson
(1914–1988)

Emmett Robinson and his wife, Pat, were founding members of the Footlight Players, a community theatre group that still actively produces plays. Robinson served as the managing director until he died. The group purchased an old cotton warehouse on Queen Street in 1934 and turned it into a usable venue over a period of years. Emmett wrote, directed, starred in, and produced plays of all types. He wrote *You Too Can Sing*; *Singers and Speakers Handbook*; and *Sing Well, Speak Well* with Albert Fracht and *Where There's Smoke*. He graduated from and taught at the College of Charleston and had a master's of fine arts from Yale. He was the moving force in a dynamic and vibrant theatre program, nurturing and inspiring all who chose to participate. He married Patricia Colbert, and they had two daughters. (Portrait painted by William Halsey hanging in the Dock Street Theatre lobby.)

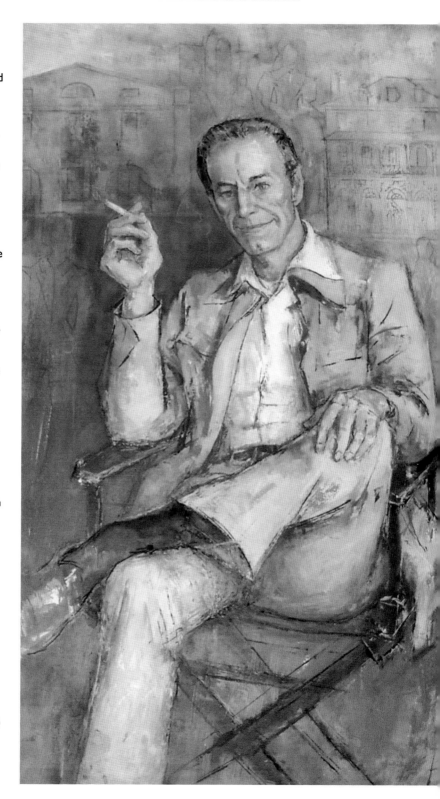

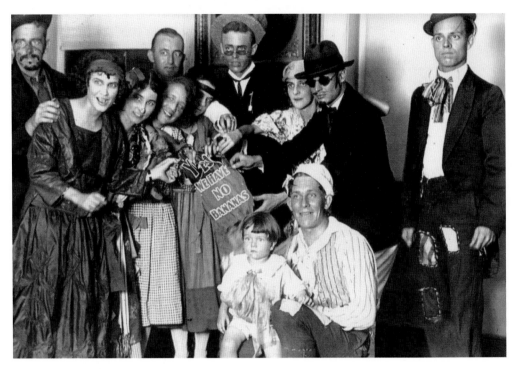

Yes, We Have No Bananas
Keith Johnson is on the far right in this 1920s photograph of the cast of a play performed at the Dock Street Theatre. There has been an active theatrical venue in Charleston since 1736, when Charleston became the first American city to have a building specifically designed for staging plays. The original building was destroyed by fire in 1740, and the building now in use was originally constructed as the Planters Hotel in 1809. It was remodeled by the WPA in the 1930s with Albert Simons as the architect. Charleston Stage, founded by Julian Wiles, has been in residence at the Dock Street Theatre since 1978. (Courtesy of Eugene Johnson DeVeaux.)

Alicia Rhett (1915)
Alicia Rhett was discovered in a play at the Dock Street Theatre and was chosen to play India Wilkes in the David O. Selznick production of *Gone with the Wind*. She enjoyed the experience but chose to return to Charleston and concentrate on her art. She is an accomplished portraitist. She specialized for a time in painting children, and her children's portraits can be seen on the walls of many of the old Charleston houses. (Publicity still for Selznick International Pictures.)

John Minott Rivers (1903–1988)

With a degree in economics from the University of Pennsylvania's Wharton School, John began his career as a banker and securities manager. In 1938, John Rivers became president of the South Carolina Broadcasting Company operating WCSC Radio. He later bought the company and, in 1953, he brought WCSC-TV on the air. John Rivers was a collector of early radio and television equipment, and after he died, his family gave his collection to the College of Charleston and endowed the John M. Rivers Communications Museum. He married Martha Robinson, and they had three children. (WCSC.)

Happy Rain

"Channel 5 is now alive!" Those were the words Charlie Hall used to open the first broadcast from Channel 5 when it went on the air in 1953, the second television station in South Carolina. By the early 1960s, Al Stone hosted a dance show for teenagers who all did the shag. "Happy Rain" Rainee Evans had a children's show that was racially integrated and included handicapped children. Carroll Godwin had an afternoon talk show, and Ken Klyce was the news anchor. Charlie Hall was the weatherman. (WCSC.)

Frances Ravenel Smythe Edmunds (1918–2010)

Frances Edmunds was the founder of the Historic Charleston Foundation in 1947, which was the first organization in the country to establish a revolving fund to acquire and preserve structures of historic significance. The first Festival of Houses was conducted in 1948. The model created by Frances Edmunds was copied by historical societies all over the country with phenomenal success. It is supported by its Annual Festival of Houses and Gardens and its International Antiques Show and generous donors. She was married to S. Henry Edmunds. (Photograph by Thomas P. Ford; courtesy of the Historic Charleston Foundation.)

Jane Lucas Thornhill (1925)

Jane Thornhill was one of the first licensed Charleston tour guides. She has conducted tours since 1952 until today. Her passion is preservation, and she has served on the boards and held positions in the Historic Charleston Foundation and the Preservation Society. She attends the Board of Zoning Appeals and defends every property and neighborhood threatened. She was born and raised in Charleston and tells wild tales of her youth in the old Charleston accent that she has never lost. She is married to Van Hoy Thornhill. (Photograph by the author.)

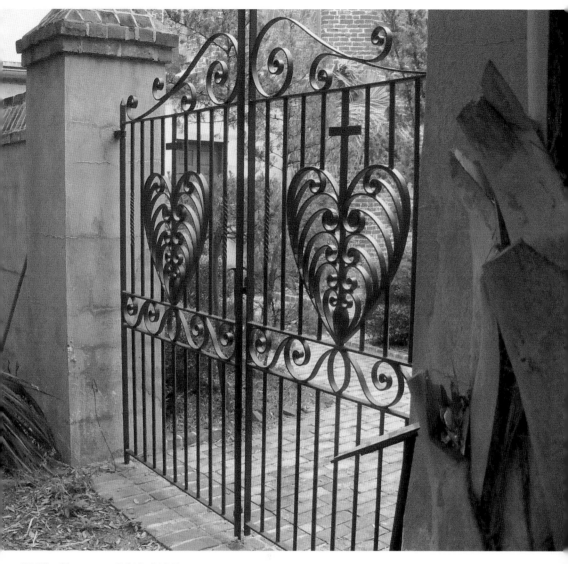

Phillip Simmons (1912–2009)

Phillip Simmons learned the trade of blacksmithing from Peter Simmons, who took him as an apprentice when he was 13 years old. The need for traditional blacksmith services waned as cars replaced horses. In the early 1940s, Jack Krawcheck commissioned Simmons to design and craft a gate for the back of his clothing store on King Street. This was the first iron gate Simmons ever made, and it took his talents into a new direction. Simmons's work became more decorative and artistic as he designed balconies and window grills and gates. The National Endowment for the Arts gave him a National Heritage Fellowship in 1982. He was inducted into the South Carolina Hall of Fame in 1994, was given the Order of the Palmetto in 1998, and received an Elizabeth O'Neill Verner Award in 2001. *Charleston Blacksmith, the Work of Phillip Simmons* was a biography written by John Michael Vlach in 1981. (Photograph by the author.)

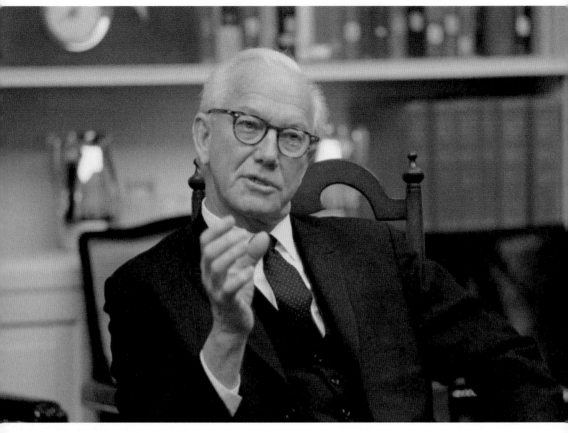

Lucius Mendel Rivers (1905–1970)
Mendel Rivers served in the House of Representatives for 30 years reaching the position of chairman of the Armed Services Committee. He was in that position during the Vietnam War and when the Naval Shipyard was located in Charleston. His background is interesting because he was born in Gumville and took six years to graduate from Charleston High School, failed to graduate from the College of Charleston or the University of South Carolina School of Law, but passed the bar exam in 1932. He was elected to Congress in 1940, and his first bill proposed building an oil pipeline from Mississippi to the East Coast to reduce transportation costs, but it did not succeed because it was opposed by "Big Oil" interests. In the 1950s, he opposed all civil rights legislation. On the Armed Services Committee, he tried to provide the military with everything it needed. He linked military salaries with the consumer price index, so that they not only got a raise but were assured of future raises, and he tied retirement pay to the same index. He married Margaret Middleton, and they had three children. (Photograph by Yoichi R. Okamoto; courtesy of the White House Press Office.)

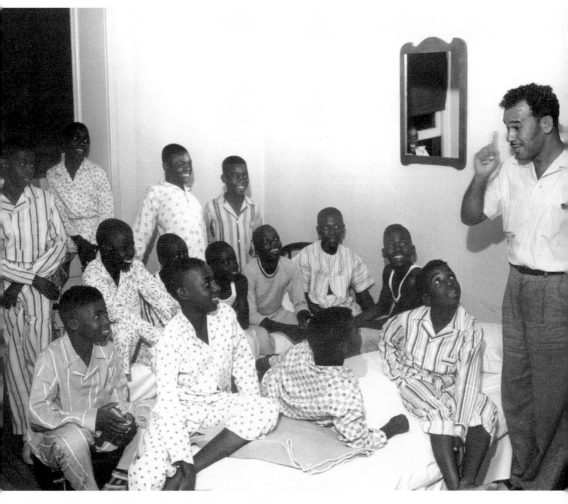

Cannon Street All-Stars Baseball Team, 1955
Pictured are, from left to right, (first row) John Bailey, Leroy Carter, Vernon Gray, and John Rivers; (second row) Carl Johnson, Arthur Peoples, Vermot Brown, George Gregory, Norman Robinson, and Maurice Singleton; (third row) John Mack, Allen Jackson, Leroy Major, Charles Bradley, and coach Walter Burke. In 1955, this was one of four African American teams registered with Little Leagues of America in Charleston. The teams with white players refused to play against them to complete the playoffs that Little League required for its World Championship games in Williamsport, Pennsylvania. This team was chosen to attend the finals based on the white teams' forfeiture by refusing to play. The team took a school bus to Williamsport and stayed in the Lycoming College dormitory and went to the World Championship games, where the fans cheered for them and asked for autographs but they did not play. Other teams were integrated, and the cafeteria meals were integrated, but Little League enforced its rule requiring progressive playoff eliminations. (Little League of America.)

Bertha "Chippie" Hill (1905–1950)
Chippie Hill was born, one of 16 children, in Charleston, but the family moved to New York in 1915. She was nicknamed Chippie because she was only 14 years old and tiny when she started singing in nightclubs. She made her first recording in 1925 with Louis Armstrong playing backup. She played in Carnegie Hall in 1948 and the Paris Jazz Festival. She was hit by a car and killed in 1950. She had seven children. (Photograph by William P. Gottlieb; courtesy of the Library of Congress.)

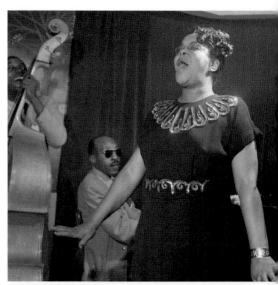

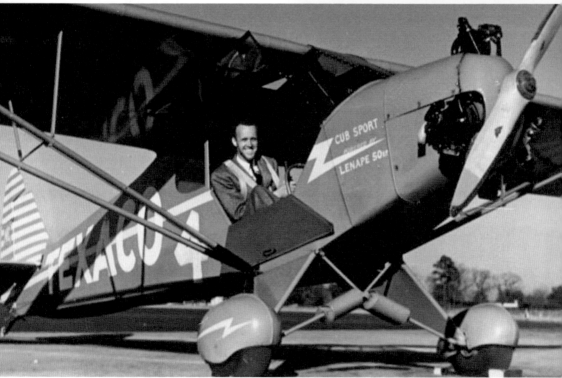

Beverly "Bevo" Howard (1914–1971)
Bevo Howard was born in Bath and worked at Hawthorne Flying Services as a line boy. He learned to fly before he was 16 years old and bought and expanded Hawthorne Aviation until his death. He flew for Delta and Eastern Airlines to support Hawthorne. He was the youngest pilot to be certified for air transport before the FAA raised the age limit to 21. He trained pilots for the Army and Air Force, but his passion was aerobatics, and he held every aerobatic championship. His plane is in the Smithsonian. He married Arden Ball, and they had five children. (Courtesy of Beverly Howard Jr.)

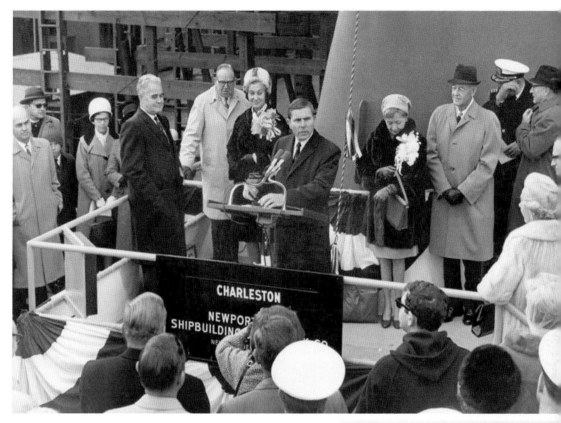

J. Palmer Gaillard (1920–2006)

J. Palmer Gaillard served as mayor of Charleston from 1951 to 1975. During his tenure, he annexed the area West of the Ashley into the city and continued to annex more areas every year he was mayor. Municipal services improved for the areas annexed, so few complained. His leadership led Charleston through the civil rights transitions without violence. His approach was a strict adherence to the law for all participants. He oversaw the building of the Gaillard Auditorium. He married Lucy Foster and had three sons. (US Navy Heritage and History.)

Gian Carlo Menotti (1911–2007)

Menotti was an Italian American composer who wrote the operas *Amahl and the Night Visitors, The Consul,* and *The Saint of Bleecker Street*, as well as 25 others. He founded the Festival of Two Worlds in Spoleto, Italy, in 1958 and its American counterpart in Charleston in 1977. His goal was to revive the popularity of opera with the general public. He won two Pulitzer Prizes and a Drama Critics Circle Award for his work. He left the Charleston Spoleto Festival in 1993 to direct the Rome Opera. He had one adopted son, Francis "Chip" Phelan. (Courtesy of William Struhs.)

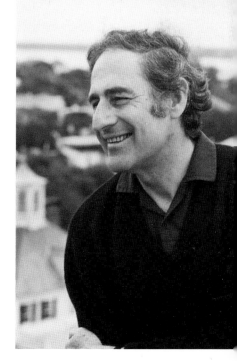

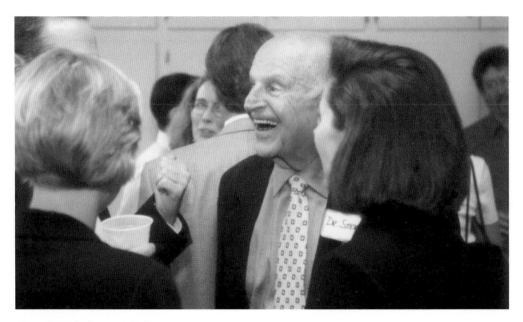

Theodore S. Stern (1912)

Born and raised in New York, Ted Stern was living in Charleston when he retired as a captain after a 28-year Navy career. He became the president of the College of Charleston in 1968, the year the first African American student was admitted. When he retired from the college, it had become a state university and had grown to 5,300 students. He became the first chairman of the Board of the Spoleto Festival and served in that position from 1977 to 1985. He and Menotti worked together to bring their vision to reality in a sustainable way. (Courtesy of the Coastal Community Foundation of South Carolina.)

Nathan Addlestone (1913–2001)

Nathan Addlestone was the only one of three brothers who did not go to college. He worked with his father, and together they built a successful international company salvaging textiles and metals. He used his fortune to support and encourage education. In 1975, he endowed the Addlestone Hebrew Academy and in 1979 established the Addlestone Foundation, which continues to support local charities focusing on education but including a wide range of other worthy causes. In 1989, he and his wife, Marlene, gave the largest monetary gift up until that time to the College of Charleston, which established the Marlene and Nathan Addlestone Library. The Addlestones had two children, and he had two stepchildren. (Courtesy of the Charleston Jewish Federation.)

Jack Leland (1914–1999)
Jack Leland was a reporter for the *News and Courier* and a great storyteller. In World War II, he served in the Army in Italy. In the 1960s, he did a series of columns in the paper featuring the houses of Charleston and telling the stories of their owners. The first book of these was published as *50 Famous Houses of Charleston* in 1970, and it grew to 62 famous houses in 1986. He married Isabella Middleton Gaud, and they had five children. His second wife was Anne Gibbs (Barnes). (Photograph by Carl Babcock; courtesy of Cheves Leland.)

Anne Worsham Richardson (1919–2012)
Anne Worsham Richardson moved to Charleston when she was 16 years old. A painter of wildlife, she was a founding member of the Charleston Artist Guild. She had a deep respect for her subjects and operated a bird sanctuary and rehabilitation center at her home so she could observe them while alive. She was the official painter of the state's bird, the Carolina wren; the state flower, the yellow jessamine; and the state butterfly, eastern tiger swallowtail. Her work is still sold at the Birds I View gallery, which she founded with her husband, John Peter Paszek. (Courtesy of Anne Maree Lawrence.)

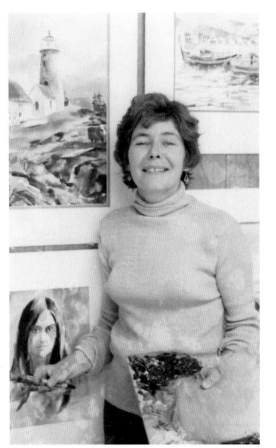

Virginia Fouche Bolton (1929–2004)
Virginia Fouche Bolton graduated from
Memminger High School and Winthrop
College with a major in art. She taught art
in the public schools of Charleston for 20
years and was beloved by her students, who
talk of her at their reunions. Many artists
credit her with their inspiration. Her subjects
are typically related to Charleston, and her
work has a dreamy quality. She opened her
gallery downtown in 1976 and became very
successful. She married Don Bolton and had
five children. (Courtesy of Donna Ciaciarella.)

Arthur Ravenel (1927)
After serving in the Marines, Arthur
Ravenel graduated from the College of
Charleston and began a career in real
estate. He served in the state legislature
from 1953 to 1959, switched to the
Republican Party, and lost five elections
before being elected to the South
Carolina Senate in 1980 and then to the
US House of Representatives in 1986,
serving until he resigned in 1994. He then
returned to the South Carolina Senate
expressly to find funding to replace the
Cooper River bridges. He did that, and
the Ravenel Bridge opened in 2005. He
married Jean Rickenbaker and had six
children. (Photograph by Nancy Santos;
courtesy of *Charleston City Paper.*)

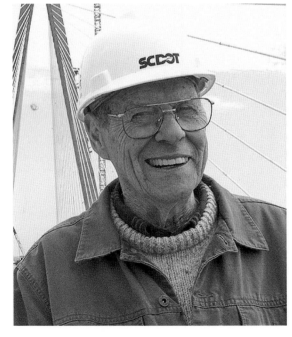

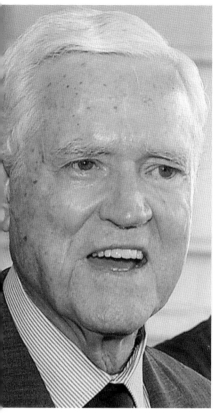

Ernest Frederick "Fritz" Hollings (1922)

Raised in Charleston, Senator Hollings graduated from The Citadel and fought in World War II, earning a Bronze Star. His political career began in the state House and led to the governor's mansion in 1958. He served in the US Senate from 1966 to 2005, retiring to the Isle of Palms. He wrote *The Case Against Hunger,* which led to the development of a food stamp program that still exists. He introduced the Gramm-Rudman-Hollings Act to limit government spending. His book *Making Government Work* was published in 2008. He married Patricia Salley, and they had four children. He then married Rita Liddy "Peatsy" Hollings, who died in 2012. (Online Office of US Senator Fritz Hollings.)

James Burrows Edwards (1927)

Dr. Edwards graduated from the College of Charleston and the University of Louisville Dental School and studied at the University of Pennsylvania. He had a career as an oral surgeon. He was elected to the South Carolina Senate and then governor in 1975, becoming the first Republican governor since 1876. President Reagan chose him for secretary of energy. He then served for 17 years as president of the Medical University of South Carolina, where the dental college is named for him. He married Ann Norris Darlington and had two children. (Courtesy of the Medical University of South Carolina.)

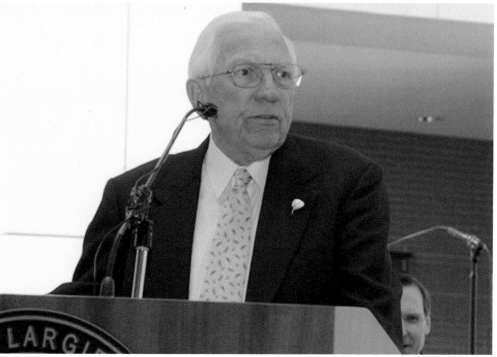

Lonnie Hamilton (1927)
Lonnie Hamilton is a renowned jazz musician whose band, Lonnie Hamilton's Diplomats, was the best jazz band in Charleston. He opened a club on Market Street where the Diplomats were the house band for decades. He is a part of the Jazz Initiative and performed at Piccolo Spoleto. He went to South Carolina State College on a band scholarship. From 1970 to 1994, Lonnie became the first African American to serve on the Charleston County Council, serving twice as chairman. The Public Services Building was named for him. He married Clarissa Hill, and they have one daughter. (Photograph by the author.)

Dawn Pepita Langley Hall Simmons (1923–2000)
Gordon Langley Hall was born in England and immigrated to Canada and then to America. In 1962, he inherited $2 million from Isabel Whitney and moved to Charleston. In 1968, he underwent a sex change operation and became Dawn Pepita. The next year, in the first legal interracial marriage in South Carolina, she married her African American butler, John-Paul Simmons. Dawn wrote biographies of Princess Margaret and Jacqueline Kennedy, and, in 1975, *Dawn: A Charleston Legend*. Jack Hitt makes her story a part of his repertoire, and Edward Ball wrote her biography. She had one daughter. (Photograph by the author.)

Oscar Rivers (c. 1939)

Oscar Rivers graduated from Burke High School and South Carolina State College and moved to Chicago to play his saxophone. He stayed there from 1961 to 1979, playing with Sonny Stitt, Quincy Jones, Stevie Wonder, B.B. King, the Temptations, and the Jackson Five. He taught music in the public schools on the side. He returned to Charleston in 1979 and formed a trio with Max Moore and Chuck King and called it Rivers and Company Band. He teaches at Memminger and Mitchell Elementary Schools and is the director of the Morris Brown AME Church Gospel Choir. His wife, Fabian, is deceased. (Photograph by Katie Gandy; courtesy of *Charleston City Paper*.)

Lucille Whipper (1928)

Lucille Whipper graduated from Avery Institute, Talledega College, and the University of Chicago where she got her master's degree. She was the director of Operation Catch-Up that tutored African American students to prepare them for college. In 1972, she was hired by the College of Charleston where she spearheaded the development of the Avery Research Center. In 1985, she was elected to the state House of Representatives and served for 10 years. She was given the Order of the Palmetto in 1996. She married Rev. Dr. Benjamin J. Whipper and had six children. (Courtesy of Lucille Whipper.)

Harvey Gantt (1943)

Harvey Gantt was born in Charleston and graduated from Burke High School. He became the first African American to attend Clemson College in 1963. He graduated with a degree in architecture with honors and went on to get a master's degree in city planning from MIT. He has made his home in Charlotte, North Carolina, where he was elected to city council and served as mayor from 1983 to 1987. He is still active in Democratic politics. He married Lucinda Brawley and had four children. (Courtesy of the Democratic National Committee.)

Manning Bethea Williams (1939–2012)

Manning was born in Charleston, graduated from the College of Charleston, and studied at the Pennsylvania Academy of Fine Arts. He taught art at the College of Charleston. He painted the mural that is in the Charleston Airport, and local people recognize the characters portrayed. His art evolved through landscapes to abstracts to war. He was a Civil War reenactor. His wife, Barbara, was the first woman named editor of a major daily newspaper in South Carolina when she became editor of the News and Courier. (Courtesy of the Post and Courier.)

Nathalie Dupree (1939)

Nathalie Dupree is the author of 11 cookbooks and has hosted over 300 national and international cooking shows on PBS, The Food Network, and the Learning Channel. Among others, she has won two James Beard Awards. She studied at the Cordon Bleu and operated a restaurant in Majorca and opened her own restaurant in Social Circle, Georgia. She was director of Rich's Cooking School in Atlanta for 10 years. She is married to Jack Bass, and they live in Charleston. (Courtesy of Nathalie Dupree.)

Jack Bass (c. 1934)

Jack Bass grew up in Columbia and has degrees from the University of South Carolina and a doctorate from Emory. He began his career as a newspaper reporter and editor but spent most of his career as a professor of journalism. He taught at Duke, South Carolina State, University of South Carolina, University of Mississippi, Emory, and currently at the College of Charleston. He has authored or coauthored nine books dealing with the South, Southern politics, race relations, and South Carolina. He also produced a course and a documentary for PBS. He is married to Nathalie Dupree and has three children from a previous marriage. (Courtesy of Jack Alterman Studios.)

Harriet McDougal Rigney (1939)

Harriet moved with her parents, Adm. William Popham and Louisa McCord Stoney, to Charleston, her mother's hometown, when her father took command of the Charleston Naval Shipyard. She graduated from Radcliffe College and worked as an editor at various New York publishing houses, eventually becoming vice president and editorial director of Charter Communications. In 1977, she returned to Charleston with her son and established her own imprint, Popham Press. She met and married James Oliver Rigney and edited all of his books. She was also the founding editorial director of Tom Doherty Associates. (Courtesy of Harriet McDougal Rigney.)

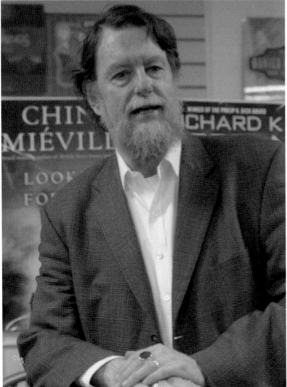

James Oliver Rigney (Robert Jordan) (1948–2007)

Raised in Charleston, Rigney was awarded a Distinguished Flying Cross, a Bronze Star, and other medals as a helicopter gunner in the Vietnam War. He returned home and got a degree in physics from The Citadel. He began writing in 1977 and produced three *Fallon* books, seven *Conan the Barbarian* books, and others. He is best known for his *Wheel of Time* series that includes 14 books. Brandon Sanderson was hired to finish the series. Rigney's first novel, *Warriors of the Altaii*, is still not published. He was married to Harriet McDougal. (Photograph by Jeanne Collins; courtesy of Harriet McDougal Rigney.)

Robert H. Rabbit Lockwood (1940) and Debi Chard

Rabbit Lockwood retired after 49 years as a harbor pilot in 2010. He grew up in Charleston, attended Gaud School, and graduated from The Citadel. His father and grandfather had been harbor pilots and owned White Stack Towing Company. He married Debi Chard, who is an award-winning anchorwoman for WCSC News. Her Debi's Kids children's charity has been successful for 20 years. She is a native of Iowa, and she and Rabbit live on Longwood Plantation, where they have marsh tacky ponies, peafowl, guineas, and assorted wildlife. There is also a polo field. (Courtesy of Debi Chard.)

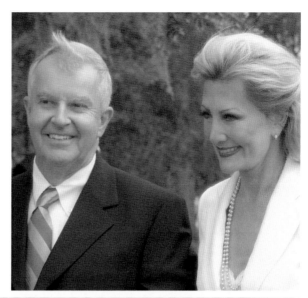

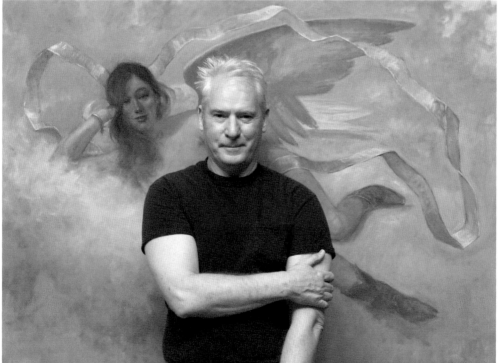

John Carroll Doyle (1942)

John Doyle is a self-taught impressionist artist who was born in Charleston. In 1997, he wrote an autobiography titled *Portrait of a Charleston Artist*. It chronicles his growth as an artist and reflects the changes in Charleston as it morphed into the tourist destination it has become. He has written three other books. His first paintings were dynamically colorful pictures of sports fish and were used on the covers of sports magazines. His work includes landscapes, portraits, and characters from the jazz and blues music scene. (Courtesy of John Doyle.)

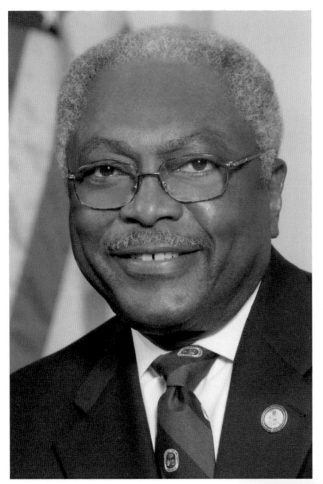

James Enos "Jim" Clyburn (1940)

Jim Clyburn grew up in Sumter and graduated from South Carolina State College. He taught for one year at C.A. Brown High School before joining the staff of Gov. John West. He was elected to the House of Representatives from the newly formed Sixth Congressional District in 1993 and has served since. He served as majority whip from 2007 to 2011, when he became assistant Democratic leader. He was instrumental in creating the Gullah/Geechee Cultural Heritage Corridor Commission within the National Parks Service. He married Emily England, and they have three children. (Courtesy of Jim Clyburn.)

Mary Moultrie (1943)

After graduation from Burke, Mary Moultrie got her licensed practical nurse (LPN) certification at Goldwater Memorial Hospital in New York. She returned to work at the Medical College Hospital where they did not recognize her LPN certification. Naomi White, a nurse at the hospital, asked the Southern Christian Leadership Conference for assistance with workers' grievances. A union was formed with Mary Moultrie as its president. The hospital did not recognize the union, and a strike was called. After the strike, Mary Moultrie went back to work for the Medical College Hospital. She later worked at the St. Julian Divine Center. In 2011, she was given the Harvey Gantt Award. (Courtesy of The Citadel Archives and Museum.)

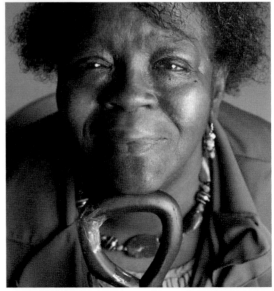

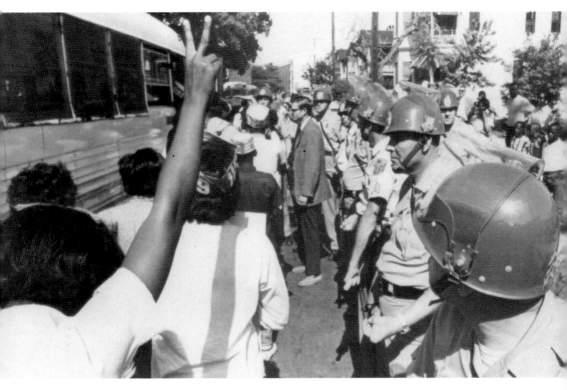

Hospital Strike (1969)

Over 300 workers from the Medical College Hospital walked out on March 19th. A week later, about a third of the service and maintenance workers at the Charleston County Hospital joined them on the picket lines. Naomi White was arrested after exchanging insults with the police. This AP Wirephoto was taken on April 26th when 100 or so people were arrested for demonstrating. Gov. Robert McNair placed the city under a curfew and sent the National Guard to insure order. On May 11, a rally was held, and 5,000 people marched, including Coretta Scott King, Andrew Young, and Rev. Ralph Abernathy. Chief of police John Conroy marched peacefully with the demonstrators. Speeches were given at the county auditorium. About a month later, Dr. James W. Colbert, father of comedian Stephen Colbert, represented the Medical College Hospital and negotiated a settlement. The legislature passed a bill granting a raise to all state employees. Governor McNair lifted the curfew, and Medical College Hospital agreed to rehire the 12 workers fired. The 1199B Union would not be recognized and soon died out. The strike had lasted 113 days. (Courtesy of AP Wirephoto.)

Mayor Joe Riley (1943)

Elected in 1975, Mayor Riley remains a most visionary and effective leader. "Mayor Riley has led a city government with an impressive record of innovation in public safety, housing, arts and culture, children's issues, the creation of park and other public spaces, and economic revitalization and development. The City of Charleston is recognized as one of the most livable and progressive cities in the United States," as quoted from the City of Charleston website. He graduated from The Citadel and the University of South Carolina School of Law and served in the state legislature. He and his wife, Charlotte, have raised two sons. (Courtesy of Mayor Joe Riley.)

Richard Porcher (1941)

Richard Porcher graduated from the College of Charleston and earned a master's of science and a doctorate degree in biology at the University of South Carolina. He taught biology at The Citadel until he retired, but his passion is botany and the natural flora and fauna of South Carolina and its restoration and preservation. He is nurturing a longleaf pine forest on land that he owns. His books include *Wildflowers of the Carolina Lowcountry*, *The Story of Sea Island Cotton*, and *Carolina Gold Rice*. He married Cynthia Holl and has two children. (Courtesy of Dorothy Porcher Holland.)

Josephine Humphreys (1945)
Josephine Humphreys is a graduate of Ashley Hall, Duke University, and Yale where she got her master's of arts degree. She also studied at the University of Texas before returning to Charleston to teach English and write. Her first three books, *Dreams of Sleep, Rich in Love, and The Fireman's Fair* are recognizably local and seem to have a character that represents each reader. *Rich in Love* was made into a movie in 1993. *Nowhere Else on Earth* is set during the Civil War and won the Southern Book Award in 2001. She is married to Tom Hutcheson. (Photograph by Avery Locklear, used with her permission.)

Suzannah Smith Miles (1947)
Suzannah Smith grew up in Charleston and attributes her lifelong interest in history to finding a Revolutionary cannonball in her yard when she was five. She has been called the "best armchair historian in South Carolina." Her personal, informal style makes the history she presents both entertaining and informative. Her writings appear weekly in the *Moultrie News* and monthly in *Charleston Magazine*. She has written 16 books and is researching several more. She spent a decade in Gettysburg writing about the Civil War. Her subjects include Charleston and the East Cooper area, Sullivan's Island, and the Isle of Palms. (Photograph by Bert Danielson; courtesy of Suzannah Miles.)

Robert Rosen (1947)
Robert Rosen grew up in Charleston and graduated from the University of Virginia, earned a master's of arts at Harvard, and graduated from the University of South Carolina School of Law. He is listed in the *Best Lawyers in America*. His practice focuses on family law. He has had eight books published: *A Short History of Charleston, Confederate Charleston, The Jewish Confederates, Charleston, a Crossroad to History, Saving the Jews: Franklin D. Roosevelt and the Holocaust, Straight Talk About South Carolina Divorce Law,* and *The First Shot*. He shares his practice with his wife, Susan Comer. They have three children together. (Courtesy of Robert Rosen.)

Jack Arthur McCray (1947–2011)
Jack McCray grew up in Ansonborough and went to Claflin College. He was in the crowd of students that state troopers fired buckshot into during a civil rights demonstration in 1968. After graduation, he worked for the *News and Courier* as a reporter and hosted a jazz program on WSCI Radio. He and Osei Chandler started a soccer team called the Little Peles in 1981, and the team won the state championship. His passion was always jazz, and he helped organize the Piccolo Jazz After Hours event. He wrote *Charleston Jazz* for Arcadia Publishing. (Courtesy of the *Post and Courier*.)

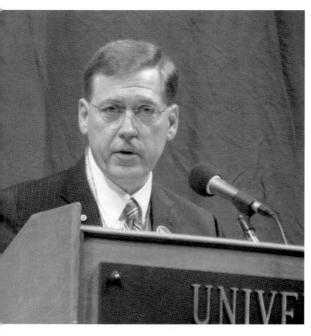

Glenn McConnell (1947)

Glenn McConnell graduated from the College of Charleston and the University of South Carolina School of Law. He practiced labor relations law with the Charleston Naval Shipyard but retired to run CSA Galleries, which sold Civil War artifacts until 2009. McConnell was first elected to the state senate in 1980 and remained there until he became lieutenant governor in 2012, serving as president pro tempore from 2001. He was instrumental in raising the *Hunley* submarine and creating the Hunley Museum. He is an active Civil War reenactor and supports flying the Confederate flag on the state house grounds in Columbia. (Courtesy of the South Carolina Republican Party.)

Chief Reuben Greenberg (1943)

Reuben Greenberg grew up in Texas, graduated from San Francisco State, and earned his master's of arts degree from the University of California, Berkeley. He came to Charleston in 1982 as the chief of police and served until his retirement in 2005. He got the policemen out of their cars and onto the streets, found incentives for them to get college degrees, and reduced crime by 11 percent while the population increased 64 percent. His approach was successful, and he became a national celebrity. (Photograph by Grace Beahm; courtesy of *American Jewish Life Magazine*.)

Anita Zucker (1962) and Jerry Zucker (1949–2008)

Born in Israel of Holocaust survivors, Jerry Zucker was brought to Florida when he was three by his parents. He graduated from the University of Florida with a triple major in mathematics, chemistry, and physics and then earned a master's in electrical engineering from Florida State. His first major invention came when he was in high school, and he continued to make innovative discoveries until he held 350 patents. He was as brilliant in his business moves as he was in his scientific work, creating the InterTech Group that became a multibillion-dollar, family-owned conglomerate that owns the Hudson's Bay Company, the Carolina Ice Palace, a share of the Stingrays Hockey Team, and companies associated with his patents. His philanthropic work reflected the same brilliance as he set out to change the world and did. Jerry Zucker Middle School was named for him to honor his contributions to education. The couple moved to Charleston in 1978, and Anita taught elementary school. Philanthropy was always a part of who they were. Anita Zucker was giving back when she had little to give but her time and talents. She serves on numerous boards and shepherds charitable contributions that reflect her passion for education. A Jerry Zucker Award is given to a hockey player each year for service to the community, and the team has many charitable functions. When Jerry died, Anita became chairperson and CEO of InterTech Group, and her son Jonathan became president of InterTech. (Courtesy of Anita Zucker.)

William Hershell Sharpe (1950)

Bill Sharpe was born in Charleston and graduated from West Ashley High School. After earning a degree from Emory University, he returned to Charleston and began work in radio and television. He has worked at Channel 5 Television for more than 38 years, sharing in Emmy and Peabody Awards for excellence. When Hurricane Hugo hit Charleston in 1989, it was Bill Sharpe who stayed on the air almost 24/7 to coordinate recovery efforts and inform people about where to seek assistance. He married Aimee Cheves, and they have three children. (Courtesy of William Sharpe.)

Rob Fowler (1960)

Rob Fowler was born in New Orleans and educated at Georgia Southern, Mississippi State, and Oregon State University. He has been the chief meteorologist at WCBD since 1987. His coverage of Hurricane Hugo earned him the Meteorologist of the Year Award from the National Weather Association, and his work with Toys for Tots earned him the Order of the Palmetto in 2007. He caused a sensation when he shaved his mustache off for the Cancer Society and has not grown it back since. He is married to Cara, and they have three children. (Courtesy of Rob Fowler.)

Opening Day Crowd at the Miami Pop Festival—A Return to Page 6

THE MEMPHIS DEBUT OF THE JANIS JOPLIN REVUE

BY STANLEY BOOTH

Rusty Burbage (1950)
On the cover of the *Rolling Stone,* yes, that's Charleston's own Rusty Burbage, front and center, at the Miami Pop Festival in December 1968. Terry Reid was singing "Bang Bang" when the photograph was taken. Rusty had gone to Miami with his friends Mike Dangerfield and Jack White. Another image of all of them appeared inside the same issue of *Rolling Stone,* but only Rusty made the cover. Chuck Berry and Marvin Gaye also played. Rusty grew up to become a drug counselor. (Courtesy of Rusty Burbage.)

Rick Smith (1950)
Rick Smith grew up in Charleston playing in garage bands and local clubs. He had a nightclub on Folly Beach called Alice Underground. In 1973, he left Charleston for Hollywood and worked as an assistant engineer, recording Stevie Wonder, Tom Waits, and Frank Zappa, getting credit on their albums. He now lives in Hawaii and works as the house manager of the Honolulu Symphony and sings blues as Haleiwa Slim. (Courtesy of Rick Smith.)

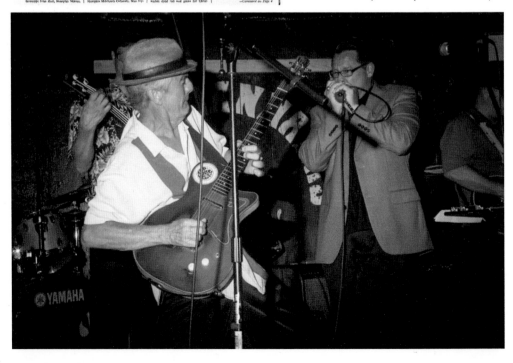

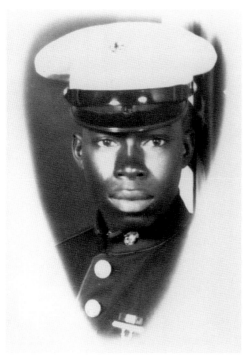

Ralph H. Johnson (1949–1968)

Ralph H. Johnson was born and educated in Charleston and entered the Marine Corps in 1967. He was serving as a private first class in Vietnam when he found himself in a small bunker with two other marines under serious attack. A live grenade landed in their space, and he shouted a warning and threw himself onto the grenade. He was killed by the explosion. He was awarded the Medal of Honor posthumously. The VA Medical Center in Charleston was named in his honor in 1991, and a guided missile destroyer was named for him in 2012. (Courtesy of the US Marine Corps.)

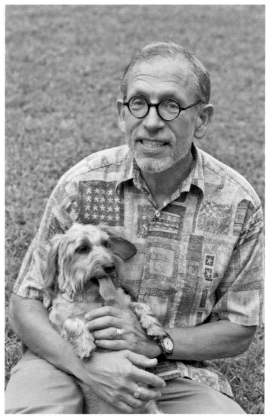

Harlan Greene (1953)

Harlan Greene graduated from the College of Charleston and did graduate work at Stanford and the University of South Carolina. He is the senior manuscript and reference archivist at the Addlestone Library Special Collections. He has also worked for the Historical Society Library in the South Carolina room at the county library and with the Avery Research Center. He has written three novels, including *The German Officer's Boy*, books on the slave system and the Charleston Renaissance, and numerous articles. (Photograph by Laura Olsen Imagery; courtesy of Harlan Green.)

Jack Hitt (1957)

Jack Hitt is a raconteur who has found fame and fortune as an author, radio personality, and stage performer but still does not have a job, according to his mother. His 1994 book *Off the Road* was used in making the movie *The Way*. In 2012, he published *A Bunch of Amateurs: A Search for the American Character*. His radio appearances include *This American Life* and *Nine to Noon* on Radio New Zealand National. His one-man stage show *Making Up the Truth* sold out at the 2012 Spoleto Festival. (Photograph by Aaron Harrow; courtesy of Jack Hitt.)

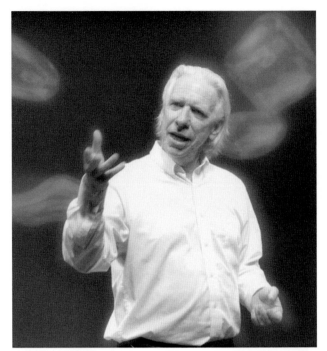

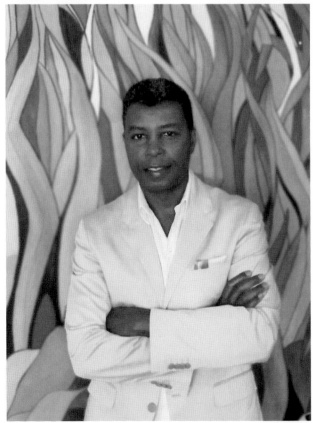

Jonathan Green (1955)

Jonathan Green was born and raised by his grandmother in Gardens Corner near Beaufort. His mother lived in New York, and he visited with her during holidays. After graduating from Beaufort High School, he enlisted in the military and was sent to North Dakota. After his military service, he graduated from the Art Institute of Chicago in 1982 and returned to South Carolina. His art is a celebration of the color, liveliness, and deep spirituality of his Gullah culture. His affection for his subjects radiates from the canvas. His studio is on Daniel Island. (Courtesy of Jonathan Green.)

Beth Daniel (1956)

Beth Daniel is a professional golfer from Charleston who played collegiate golf at Furman. She won the US Women's Amateur tournament in 1975 and was on the 1976 championship team. She turned professional in 1978 and was on the LPGA tour in 1979, where she was selected Rookie of the Year. In 1990, she won the Mazda LPGA Championship and was named AP Female Athlete of the Year. She is in the World Golf Hall of Fame. (Photograph by Wojciech Migda; courtesy of Beth Daniel.)

David Farrow (1952)

David grew up in Charleston, attended George Washington University, and graduated from the College of Charleston. He has worked in journalism and broadcasting and published articles in several magazines. He is the author of *Charleston, SC: A Remembrance of Things Past* and *The Root of All Evil*, a novel. He founded a tour-guide company that gave hilarious, irreverent tours and produced videos. In 2011, he ran for mayor as a conservative and now has a web presence as *The Charleston Times*. The goal is to have this evolve into a local television network where the "grace of old Charleston meets the vibrancy of new Charleston." (Photograph by Pete Peters; courtesy of David Farrow.)

Sallie Krawcheck (1964)

Sallie Krawcheck graduated from Porter-Gaud School, the University of North Carolina, and received her master's of business administration from Columbia Business School in 1992. She began her career at Sanford C. Bernstein as a research analyst, rising to CEO. After taking the business out of investment banking to concentrate on independent research, *Fortune* called her "the Last Honest Analyst." She has turned around two of the country's largest wealth management businesses, Smith Barney and Merrill Lynch. She married Gary Appel and has two children. (Courtesy of Sallie Krawcheck.)

Stephen Tyrone Colbert (1964)

Stephen Colbert graduated from Porter-Gaud School and attended Hampden-Sydney, graduating from Northwestern University in theatre. His career started at Chicago's Second City improv troupe. In 2005, *The Colbert Report* debuted on Comedy Central with Stephen as its star and executive producer. The satirical news show has won numerous Emmy Awards and two Peabody Awards. In 2012, *Time* magazine named Colbert among its "100 Most Influential People in the World." A best-selling author who launched his own Super PAC to lampoon the electioneering system, he sort of almost ran as "President of the United States of South Carolina." The real Stephen Colbert is married to Evelyn McGee and has three children. (Photograph by Martin Crook; courtesy of *The Colbert Report* / Comedy Central.)

The Charleston Nine (June 18, 2007)

Pictured from left to right are (top row) Bradford Baity, Mike Benke, and Melvin Champaign; (center row) Earl Drayton, Michael French, and William Hutchinson; (bottom row) Mark Kelsey, Louis Mulkey, and Brandon Thomson. These nine men, all of them dedicated firefighters and active participants in the community, died in the Sofa Super Store fire. Their deaths have been memorialized in many ways. Studies have been done to investigate the circumstances of their deaths, and reports have been made. It remains a very tragic story. (Photograph by Bill Murton; courtesy of the City of Charleston.)

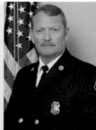
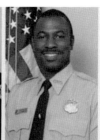

Bradford Baity | Mike Benke | Melvin Champaign

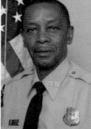
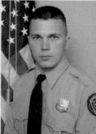
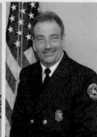

Earl Drayton | Michael French | William Hutchinson

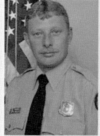
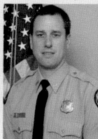
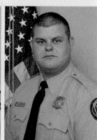

Mark Kelsey | Louis Mulkey | Brandon Thomson

Darius Rucker (1966)

Darius Rucker rose to fame as the lead singer for the rock group Hootie and the Blowfish, which formed when the four members were students at the University of South Carolina in 1986. The band had six Top 40 hits. In 2008, Darius signed with Capital Records as a country singer, and a song on his first album went to number one. The next year, he won the New Artist Award. He has one daughter with a former girlfriend, and he and his wife, Beth, have a daughter and a son. Darius is very active in charitable causes and events in Charleston. (Photograph by Chris Hollo; courtesy of Darius Rucker.)

Thomas Gibson (1962)

Thomas grew up in Charleston performing in Julian Wiles's Young Charleston Theater Company productions. He attended the College of Charleston and graduated in drama from the Juilliard School. His acting career includes roles on Broadway and Off-Broadway and in movies and television. Twice nominated for a Golden Globe for his role in *Dharma & Greg* and for several Screen Actors Guild awards for his work in *Chicago Hope*, he has starred in *Criminal Minds* since 2005. He is married and has three children. (Photograph by Dan Huse; courtesy of Thomas Gibson.)

The Lee Brothers (1960s)

Ted and Matt Lee grew up in Charleston and, when they went to college in the Northeast, they found themselves homesick for boiled peanuts and other Southern delicacies, so they founded a mail-order business called the Boiled Peanut Catalogue. From there, they went into writing about food experiences for magazines and then in cookbooks. Their recipes are spiced with Southern tales and customs that delight. Their first book, *The Lee Brothers Southern Cookbook*, won Julia Child and James Beard awards. Their latest book is *The Lee Brothers Charleston Kitchen*. Ted is married to artist E.V. Day, and Matt and his wife, Gia, are the parents of two sons. (Courtesy of Ted Lee.)

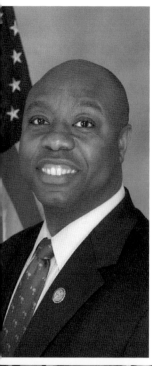

Timothy Eugene "Tim" Scott (1965)

Tim Scott attended Presbyterian College and graduated from Charleston Southern University. He owns an insurance agency and provides financial planning. In 1995, he was elected to Charleston County Council and served there until he was elected to the state legislature in 2008. In 2010, he was elected to the US House of Representatives. Tim Scott is a true economic conservative who is fighting for a balanced budget. He was appointed by Governor Haley to fill the US Senate seat vacated when Jim DeMint resigned in 2012. (Courtesy of Tim Scott.)

Shepard Fairey (1970)

Shepard Fairey began his art career as a teenager by putting cool pictures on skateboards. He graduated from Idyllwild Arts Academy and the Rhode Island School of Design. While a student, he created the rebellious "Andre the Giant Has a Posse" sticker campaign that morphed over the years into OBEY, a worldwide street-art installation and clothing line that continues to evolve and bring him worldwide attention. His work can be seen in the National Portrait Gallery, on assorted album covers, on *Time* magazine covers, and in The Institute of Contemporary Art, Boston, which calls him the most influential street artist. He designed the Obama "Hope" poster, which has been displayed at the National Portrait Gallery. He and his wife, Amanda, have two children. (Photograph by John Furlong; courtesy of Shepard Fairey.)

Johnny Williams (1979)

A teacher at James Island High School, Jim Craven, recommended Johnny to Joe Sliker, who owned 82 Queen Street and gave him his first job as a busboy. Johnny went to Trident Technical College as he moved up the ranks to become bartender. at the restaurant. Joe's daughter Ansley became his mentor, and Johnny was made general manager when he was 23 years old, becoming one of the youngest general managers in the city. John Doyle painted his portrait, calling it "A Born Leader." The painting hangs in the bar of 82 Queen Street today. George Woolston wrote the story for the *Charleston Mercury*. (Courtesy of Johnny Williams.)

Richard Todd (c. 1971)

Richard Todd (Furches) came to Charleston in 1991 after graduating from the University of South Carolina. He worked for 96WAVE Radio on the *Taylor and Todd Morning Show*. In 1996, the station changed formats, and Todd taught at Fort Dorchester High School for four years. He went back to radio first to WSC and then to WTMA to a "talk" format, discussing only local issues. He married Mary White, and they had a son, Tyler. Mary died of cancer in January 2012 after three years of treatments and surgeries that Richard talked about on the air. He resigned in March 2012. (Courtesy of Richard Todd.)

Nichole Green (1974)

Nichole Green grew up in McClellanville, graduated from the University of Virginia, and is a doctoral candidate in culture and anthropology at Duke. She has worked at Monticello, the Caroliniana Library, the South Carolina Room of the County Library, and Drayton Hall, leading her to her position as curator of the Old Slave Mart Museum. She evaluated the collection that was there and found items important enough to be put on loan at the Smithsonian. She hired a design team and wrote the text for the displays and became director of a museum that the city can be proud of. (Photograph by Bill Murton; courtesy of Nichole Green.)

Nancy Mace (1977)

Nancy Mace was the first female to graduate from The Citadel. Shannon Faulkner had been the first to enroll, but she left after only a week. Nancy's father, Brig. Gen. Emory Mace, a Citadel alum, became the commandant of cadets the year that Nancy entered in 1996. She received her master's of arts from the University of Georgia. In 2001, she wrote *In the Company of Men: A Woman at The Citadel*, which Pat Conroy calls the best book written about The Citadel experience. She is president of the Mace Group. She is married and has two children. (Courtesy of Nancy Mace.)

125

INDEX